kate spade

NEW YORK

SHE

MUSES, VISIONARIES AND MADCAP HEROINES

kate spade

NEW YORK

abrams, new york

Editor: Rebecca Kaplan
Production Manager: Rebecca Westall

Library of Congress Control Number: 2016961369

ISBN: 978-1-4197-2720-7

Printed and bound in China
10 9 8 7 6 5 4 3

Abrams books are available at special discounts when purchased in
quantity for premiums and promotions as well as fundraising or educational use.
Special editions can also be created to specification.
For details, contact specialsales@abramsbooks.com or the address below.

ABRAMS The Art of Books
195 Broadway, New York, NY 10007
abramsbooks.com

interesting
(adjective)

to pique curiosity and hold attention.

interested
(adjective)

expanding your horizons to change
your world for the better.

CONTENTS

i've long believed that the most inspiring and vibrant women in america—and around the world—are the ones who stand out in the crowd. "daring" is a word that's always in style, whether it's in reference to creating a shockingly beautiful work of art, following a wild dream, challenging the status quo, speaking from the heart, adventurous cooking or inspiring an entire generation to think about a social issue differently.

the most daring thing you can do in life is be true to yourself. individually and collectively, these women inspire us to do exactly that.

Deborah

deborah lloyd
president & chief creative officer
kate spade new york

1.

she
can
light up
a
room.

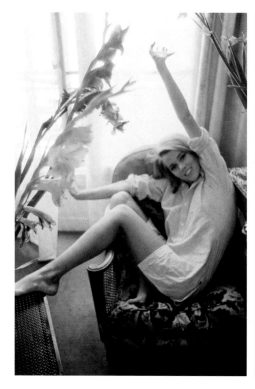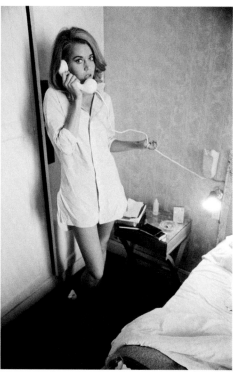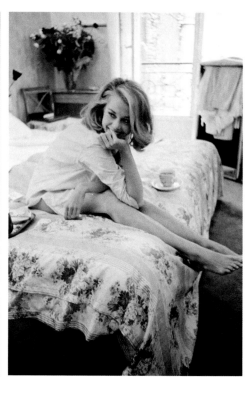

jane fonda (1937–) stretches the imagination. she's played
ingénues, sexpots and tough independents in over fifty films
and on broadway. she's taken on roles that address serious social
issues (personal courage, capitalism, war, sexuality, aging) with
grace and humor (see: *julia, tout va bien, coming home, grace and
frankie*). she inspires action on those issues in real life: she made
an exercise video that sparked a nation-wide fitness craze in
the 1980s; with fellow activists and writers gloria steinem and robin
morgan, she founded the women's media center to increase the
visibility and decision-making power of women in media. she stood
with indigenous people at standing rock sioux reservation in
north dakota to stop a pipeline from crossing ancestral lands. "the
most incredible beauty and the most satisfying way of life come
from affirming your own uniqueness," she wrote in her
second book. yes indeed.

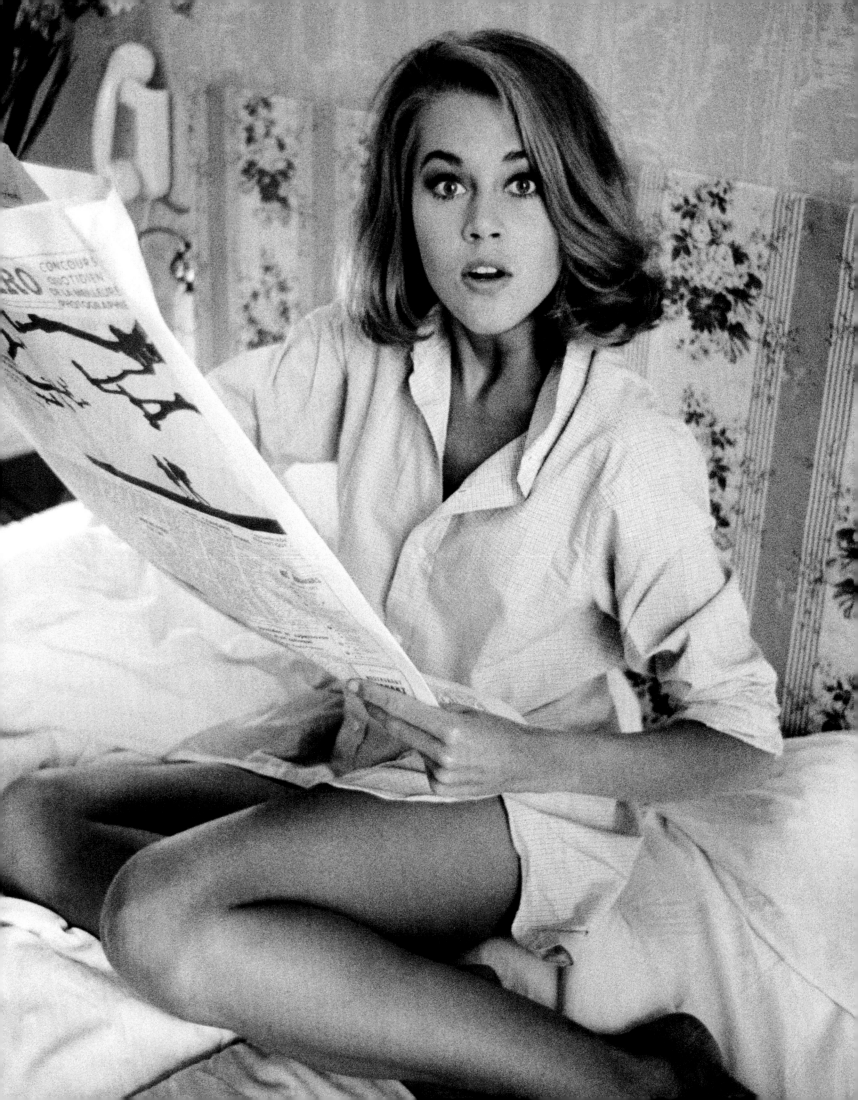

sarah sophie flicker (1975–) combined all her interests—politics, fashion, art, performing, dance—after the 2004 elections and founded an avant-garde political cabaret troupe called the citizen's band. for it she gathered dancers, actors, poets, composers, aerialists and trapeze artists; karen elson, maggie gyllenhaal, melissa auf der maur, zooey deschanel and craig wedren. they've addressed issues from voter apathy, the environment and immigration to debt, medical care and human rights across the country. she started the department of peace to produce political films and PSAs—like the one of miranda july, carrie brownstein, tracee ellis ross, sia, lena dunham, lesley gore and more— encouraging women to vote in 2012 by lip synching to "you don't own me." (lesley originally recorded the song in 1964 in the same fight for equal rights and equal pay.) she exposes anti-female legislation at the local and federal level with lady parts justice. as the creative director of art not war, she's creating campaigns calling for paid family leave. she writes about all of these issues for young adult platforms like *rookie* magazine and hello giggles. she studied law. she collects vintage clothes. she's directed music videos for karen elson and anti-fracking ones for yoko ono. she's a mother of three. her home is a gathering place for political meetings, fundraisers, band rehearsals and celebratory meals. she loves getting a bunch of people together and seeing what happens next.

"the best thing to do is create
a community around you, so that you can
talk about things...."

…most of the things that i'm passionate about doing have something to do with this universal human drama. we all share these experiences, and we forget that because we get so caught up in our own thing."

—*sarah sophie flicker*

josephine baker (1906–1975) worked as a dresser for *shuffle along* on broadway and became the show's unexpected star when a dancer fell ill. she moved to paris in the roaring '20s, danced at the folies bergère theater in a skirt made of sixteen bananas and counted pablo picasso and ernest hemingway as fans. in the 1930s she was europe's highest paid entertainer but called a "wench" in the united states. she gathered intelligence for the french resistance during world war II by smuggling messages in her sheet music, served as a sub-lieutenant in the women's auxiliary air force and received two of france's highest military honors. she marched in and spoke at the march on washington with martin luther king, jr. she adopted and raised twelve children from around the world to show that people of different races and nationalities could live in harmony. and when she returned to the united states in 1973 to perform at carnegie hall, she received a standing ovation. *before* she performed.

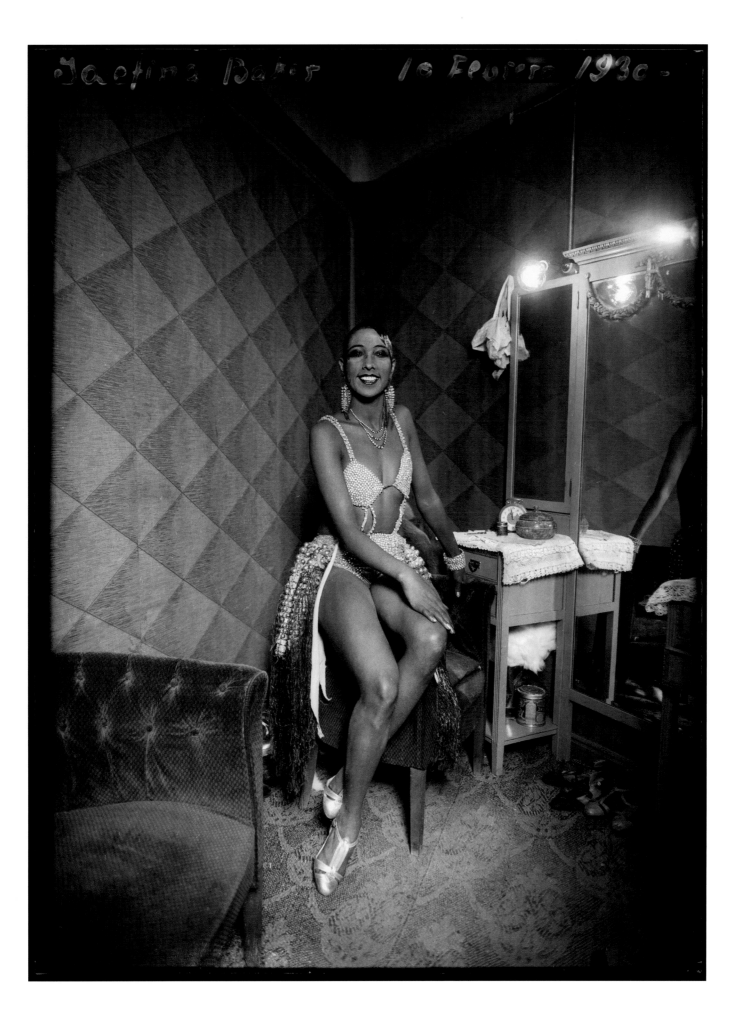

jacqueline kennedy onassis (1929–1994) turned the spotlight on others. she spoke people's languages. sometimes literally. she spoke french to the french. she gave her orange bowl speech in spanish to the latino community. while first lady, she publically celebrated the country's creative culture and invited the *crème de la crème* of artists, writers, poets, musicians and scientists to dinners and events at the white house. she supported the creation of a national cultural showcase, which is now the kennedy center for the performing arts in washington. she asked a committee of scholars to choose 1,500 significant books for the white house library and then made that list public to encourage the nation to read. when eighty million people tuned in to watch her tour of the newly restored white house in 1962, she made sure the names of individual donors who contributed antiques and to the costs of the renovation were included in the script. (side note: as part of the renovation plans, congress also declared the white house a museum to help preserve it.) while working in publishing in new york in the 1970s, she helped nurture and edit nearly one hundred tomes. even at her first job, as the *washington times-herald*'s inquiring photographer in the early 1950s, she posed witty questions to people on the street and took their picture. through it all, she handwrote timeless, gracious letters for the biggest—and smallest—of deeds.

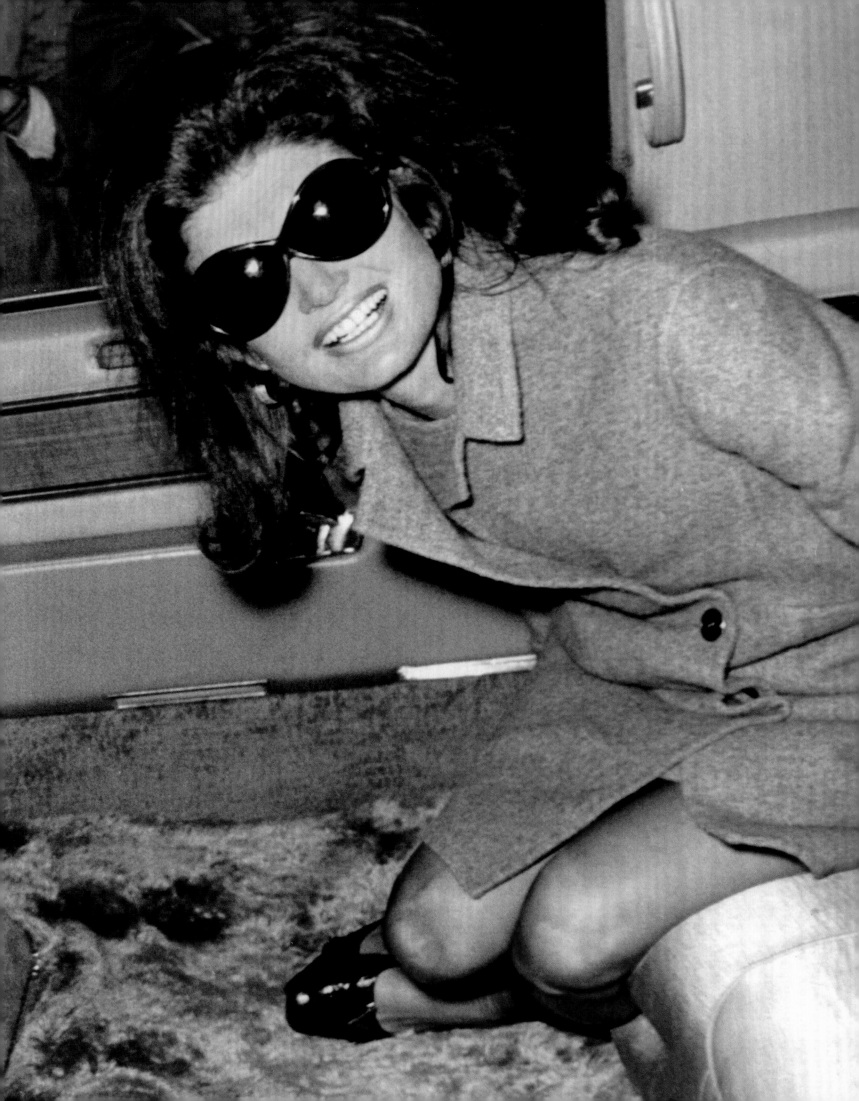

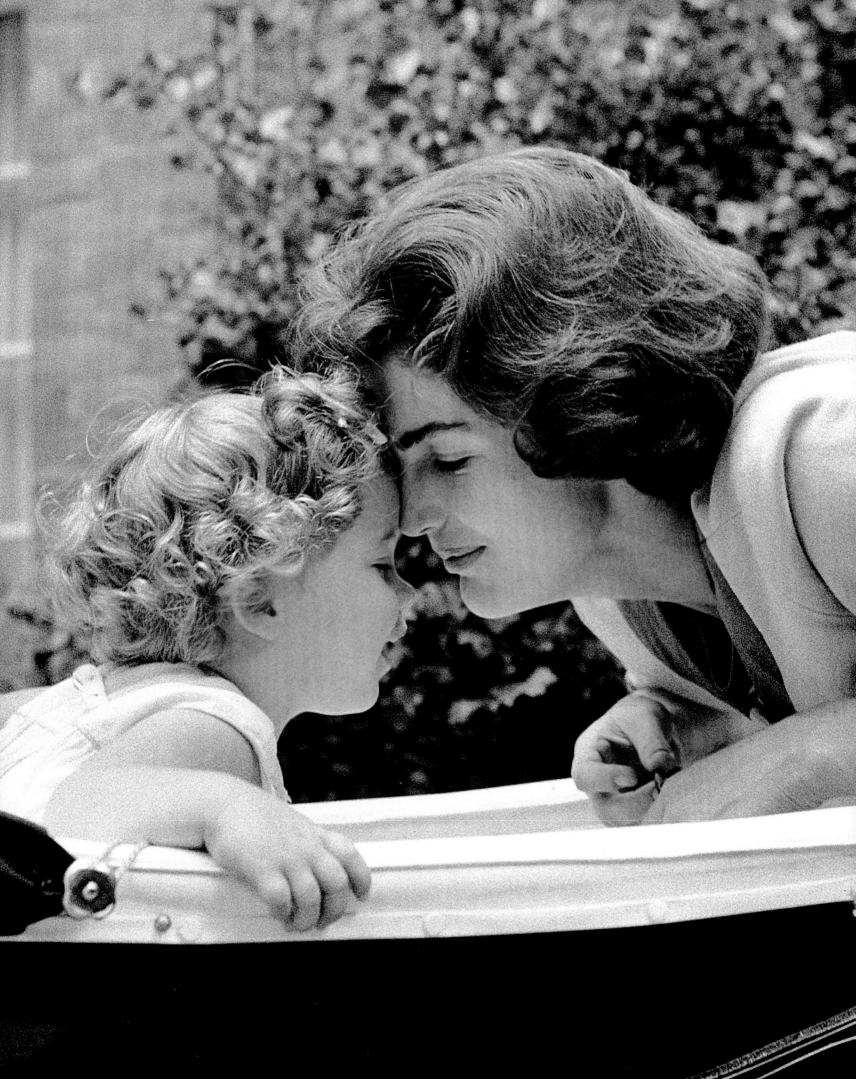

3
SMALL WAYS JACKIE SHOWED LOTS OF
GRATITUDE.

she put pen to paper within twenty-four hours. a handwritten
note went a long way.

she was personal, and often wrote about what was
special about the gift or event for a few sentences before even saying
the actual words "thank you."

she left no deed un-thanked. a private dinner with the nixons.
the sales staff at bergdorf goodman whenever she shopped.
when 1.5 million mourners sent their condolences after her first
husband died, many received notes of thanks back.

she laughs out loud but always keeps secrets.

dolly parton (1946–) has composed over 5,000 songs and writes something almost every day. she plays the banjo, guitar, piano, recorder, saxophone and the dulcimer. (it's a type of zither.) if she says she knows a song so well that she can play it backwards—she'll turn herself backwards and play it. she loves people. she loves to perform. she grew up in the great smoky mountains of tennessee in a one-room cabin with eleven siblings and sang at the grand ole opry when she was 13. she memorized the entire script of her first of twenty-five films, *9 to 5* (every. single. part.) and composed the movie's title song on set by tapping her fingernails. (listen closely and you'll hear her acrylic nails in the percussion.) she created dolly's imagination library, a literacy program that donates over ten million books to over one million preschool children every year, her own record and production companies and a theme park called dollywood, near those great smoky mountains. she's received more industry and national awards than can be listed on a page—but she calls the bronze statue of her, which stands on the courthouse lawn of her hometown of sevierville, her "greatest honor, because it came from the people who know me."

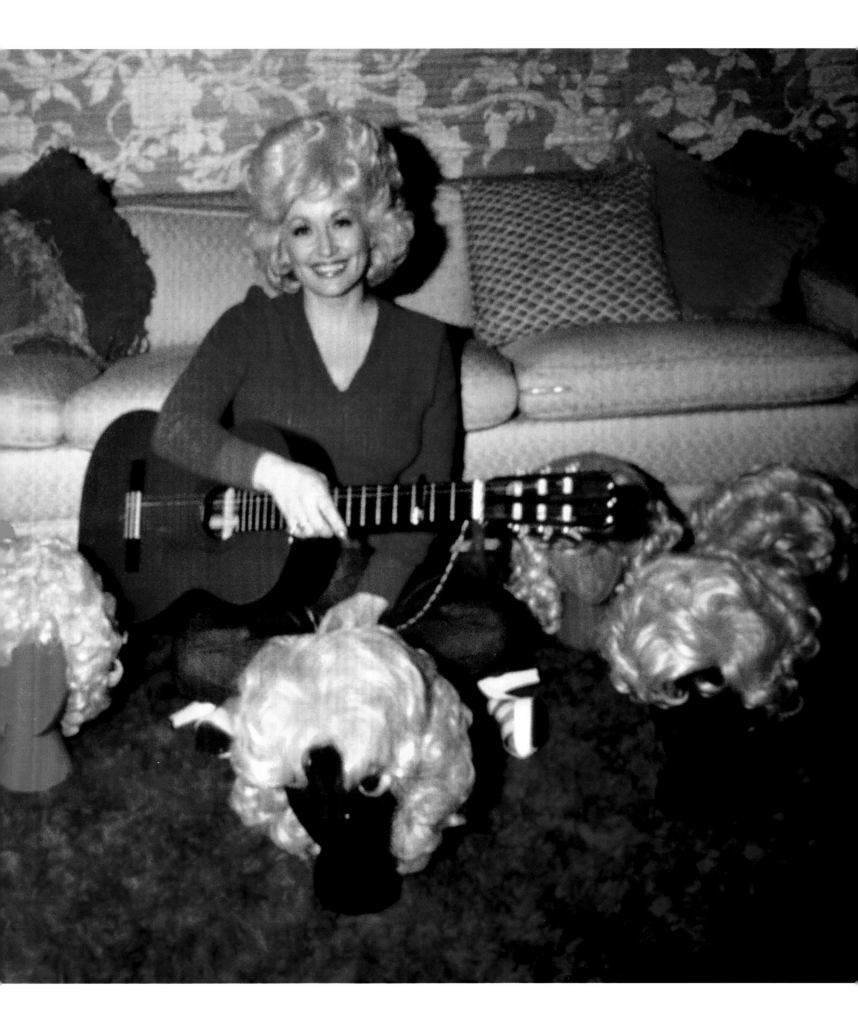

Q: "you seem to bring
people together from the north and
the south, the country and
the city, rich and poor, gay and straight,
black and white."

A: "i think that i've been at this so long that they've come to know me, they know i'm not judgmental. they know i like everybody. i want to be accepted myself, and i not only accept, but celebrate, the difference in everyone."

—*dolly parton*

she leaves a little sparkle wherever she goes.

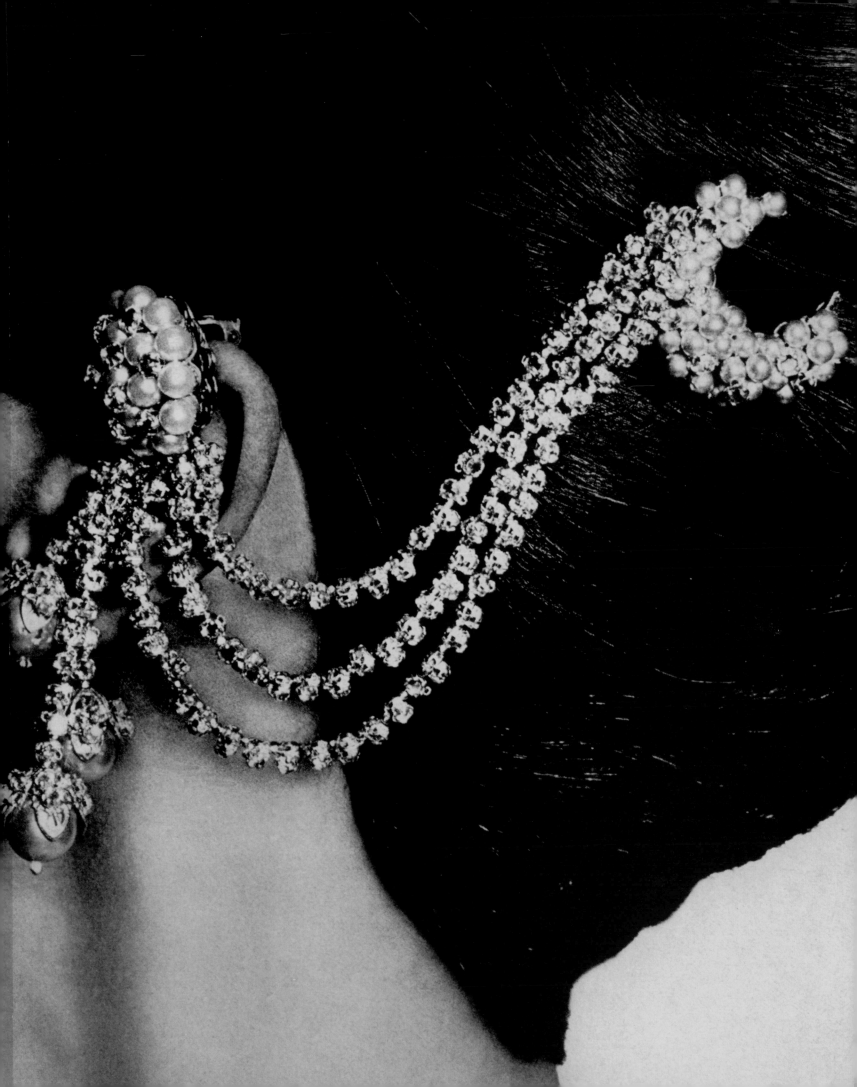

gilda radner (1946–1989) once swanned around a party
while holding her index finger to her forehead to hide a pimple.
she laughed her way through her *saturday night live* audition
before joining its debut cast. and then made candice bergen laugh
on air during a scene about the right to extreme stupidity when
candice misses a line and gilda adds her to the list. on screen,
she and bill murray made the most authentic love nerds; off-screen,
she told gene wilder on the first night they met she was going to
marry him. (she did.) lucille ball was her childhood idol and she
played her opposite desi arnaz on *SNL*. she was the first comedian
to poke fun at news anchors. (barbara walters, or "baba wawa"
as gilda said.) she thought dogs were role models for living because
of their unconditional love. she hailed from detroit, performed
in second city with dan aykroyd and john belushi, and would pick
being funny over being gorgeous any day. she was both.

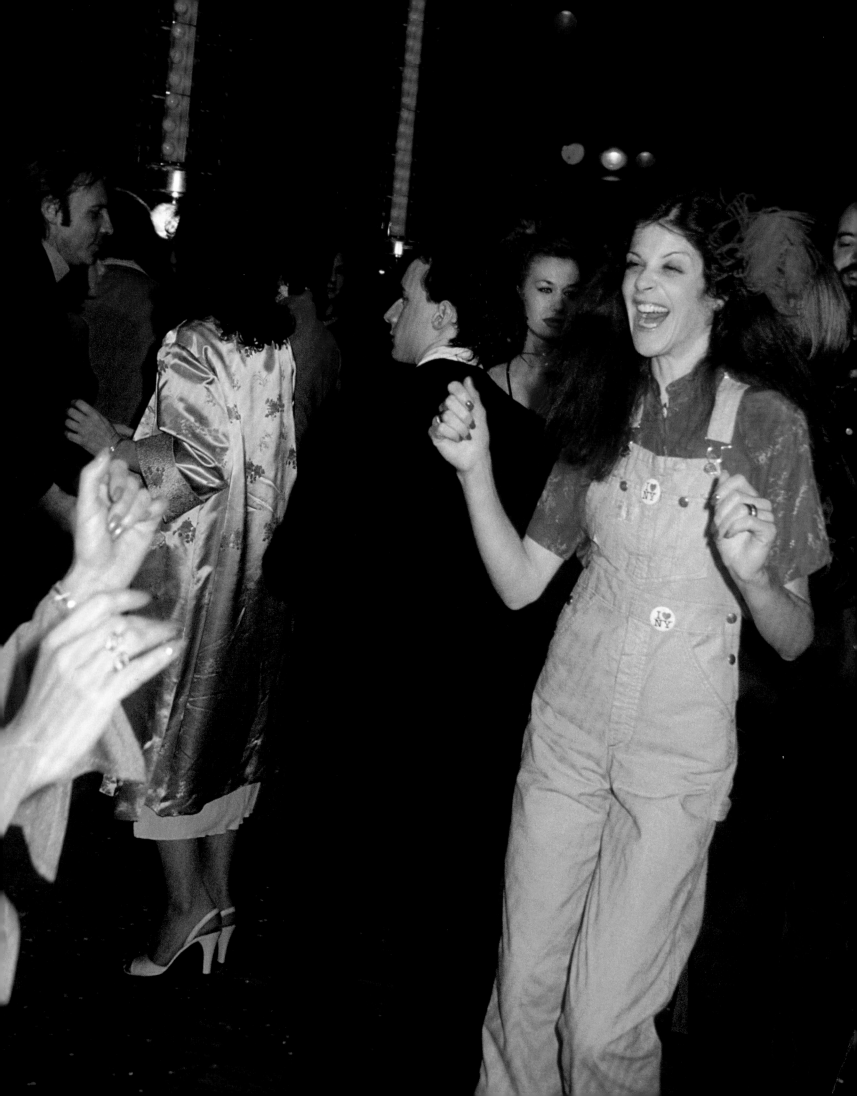

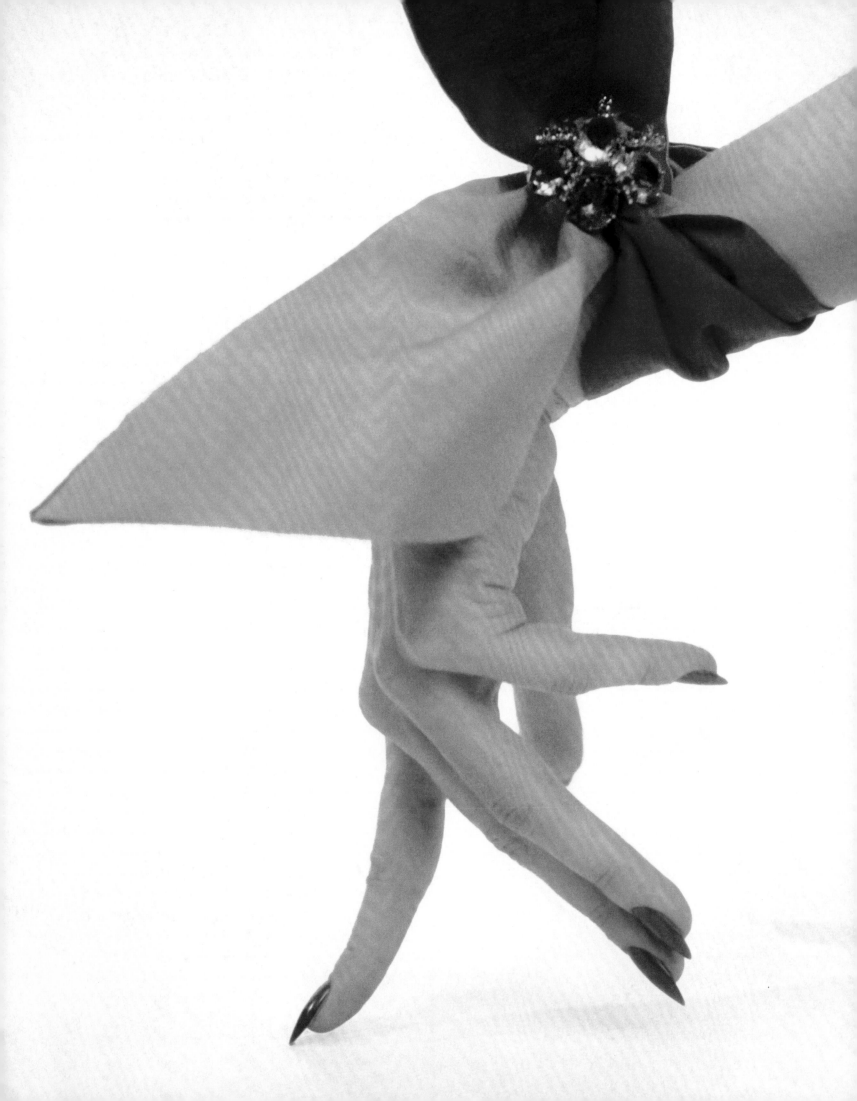

2.

she
has a way
with words,
red lipstick
and
making an
entrance.

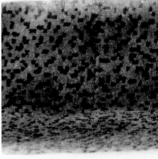

eartha kitt (1927–2008) had a voice that purred and moves to match. she played cat woman in the original *batman* television series and performed in nightclubs, film and on broadway. she spoke four languages and sang in seven. she grew up on a cotton plantation in the south, got a full scholarship to dance school in new york on a dare, lived in paris, spoke freely and unapologetically, and believed in equal education for all.

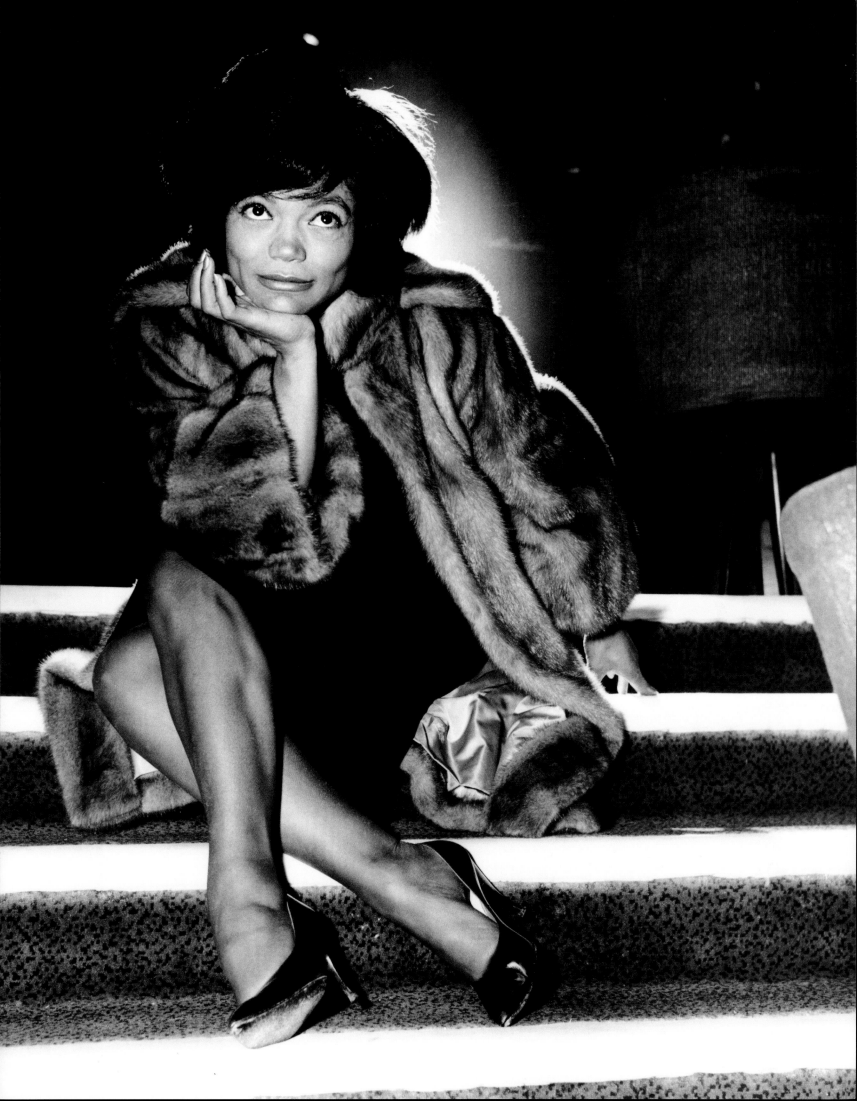

"to compromise?
what is compromising?
compromising for what?
compromising for what reason.
to compromise?
for what?
to compromise.
what is compromise.
a man comes into my life
and i have to compromise?
for what?
for what?
for what?

a relationship is a relationship
that has to be earned.
not to compromise for.
and i love relationships.
i think they're fantastic.
they're wonderful.
i think they're great.
there's nothing more beautiful
in the world than falling in love.
but falling in love
for the right reasons.
falling in love
for the right purpose.
falling in love.
falling in love.
when you fall in love,
what is there to compromise about?

yes.
i fall in love with myself.
and i want someone
to share it with me.
i want someone
to share me with me."

*eartha's answer to a reporter's question about love
and compromise, circa 1982, is pure song.*

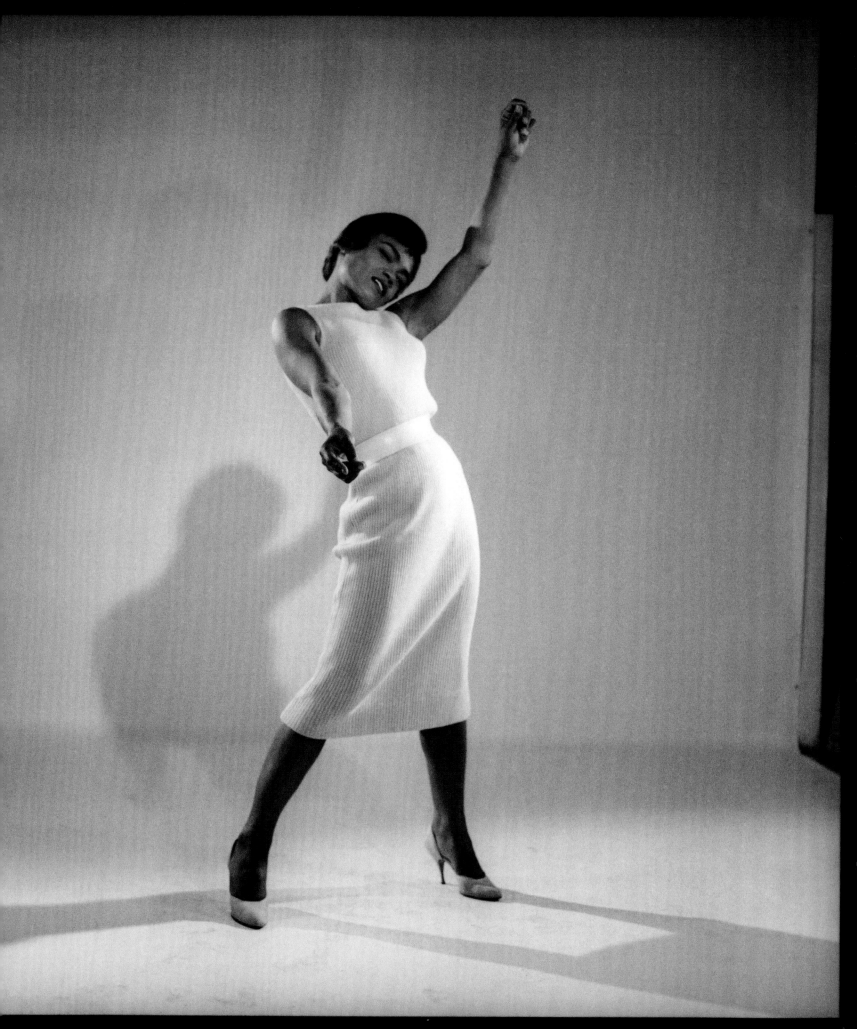

"i've always felt that clothes have the power to turn me into various superheroes..."

RECENTLY, I WAS AT A PARTY in the hollywood hills in the extravagant home of a woman who had something or other to do with *orange is the new black*, though no one could say what for sure—maybe she was a producer, or perhaps a writer, though she may have actually been the basis for a character, according to the guy serving the punch. "well, which is it?" i asked my wingman sam, a friend of the host who had brought me to the party. "how should i know?" he said, rolling his eyes. "ask your phone."

all the girls at the party looked like they'd time traveled there from the '70s: a sea of floral dresses and earth tones. myself, being a new transplant from new york, showed up wearing a leopard print mini skirt, fuchsia sweater and a red, heart-shaped handbag. i was certainly drawing attention—smiles, mostly. some with a bit of fear in them. (i'm slowly learning that bold outfits that wouldn't get a second glance in new york, in LA seem radical. the russ meyer pin-ups and kitsch california girls of yore have been replaced by granola chic. now, if you channel elle woods, people instantly assume that you're extremely interesting. or insane. or both.)

how i ended up here: i've always been an escapist—both in my life and my aesthetic. last fall, i moved to LA to avoid new york after a breakup. i had been dating my now ex-girlfriend for three years and, both being freelancers who worked primarily from home, we spent pretty much twenty-four hours a day together in a tiny manhattan apartment. after we broke up, it wasn't just that i missed her—suddenly, every minuscule action felt incomplete, and ultimately unbearable. and so, true to character, i impulsively sublet my NYC apartment and moved west.

my vision of LA before moving here was one of trashy-profound glamour: jayne mansfield spilling out of a cocktail dress, joan didion reclining on a white corvette stingray, a naked eve babitz playing chess with marcel duchamp, etcetera. however, that LA is long gone—now i'm the one living in the past. the reality today is quite different.

the city, in my six month experience, consists of yogis inhaling kale dust, uber drivers on cleanses and people blaming the alignment of the planets for why they were twenty minutes late to lunch. but the weather is great and i have a yard. still, being a true city woman, i never go outside unless absolutely necessary—i have all my necessities delivered to my house through various apps—but the idea that i could go out and sunbathe on grass if i wanted to is comforting.

when i left new york, i packed a suitcase of only my loudest, most upbeat clothing. i wanted to remedy the sadness of my breakup, and years of aesthetic experimentation have taught me that i feel happier when i indulge my most pop—even kitsch—impulses. it's like bill cunningham said: "fashion is the armor to survive the reality of everyday life." or like how an actor puts on a costume to help get into character. personally, i've always felt that clothes have the power to turn me into various superheroes: i flirt better in lace, i negotiate best in a power suit and i'm the most fun when i dress like elle woods after raiding cicciolina's closet. i dress to reflect who i am, but also to become who i want to be.

the bottom line is, it's virtually impossible to wallow in self pity while wearing leopard print and carrying a handbag that looks like a box of chocolates. and why would someone ever choose to look ordinary when you can look extraordinary?

later that night at the hollywood party, i spotted one girl standing by the fireplace in a pink PVC coat and a bright red lip. we locked eyes—it was an unspoken connection. "she's going to be my new LA best friend," i said confidently. sam rolled his eyes at me once more. "it's ok to like the way someone dresses, but fashion feelings are not the same as real feelings," he said. i'm not sure i agree. if the clothes we wear and the bags we carry are the purest, most visible manifestation of our identity, then assessing someone based on their personal style seems, if not wholly accurate, at least a good start...right?

karley sciortino (1985–) is a writer and documentarian who grew up in upstate new york, moved to london at 18 for drama school, dropped out of drama school, took up residence in an artist commune and started a blog called *slutever* to tell personal stories about her and her roommates back in 2002. today, she professionally writes about modern relationships and sexuality (a.k.a. emotional health) with a mesmeric mix of theory, social observation and commentary. other topics, too. whether publically analyzing the awkward or the everyday (like the social-sartorial effects of going to a party as an out-of-towner, above, which she chronicled for our blog), she's frank, she's funny, and conversationally, she'll quote philosophers—camille paglia, alain de botton, simone weil, to name a few—when you least expect it. she became *vogue*'s first online ~~sex~~ emotional health columnist in 2013.

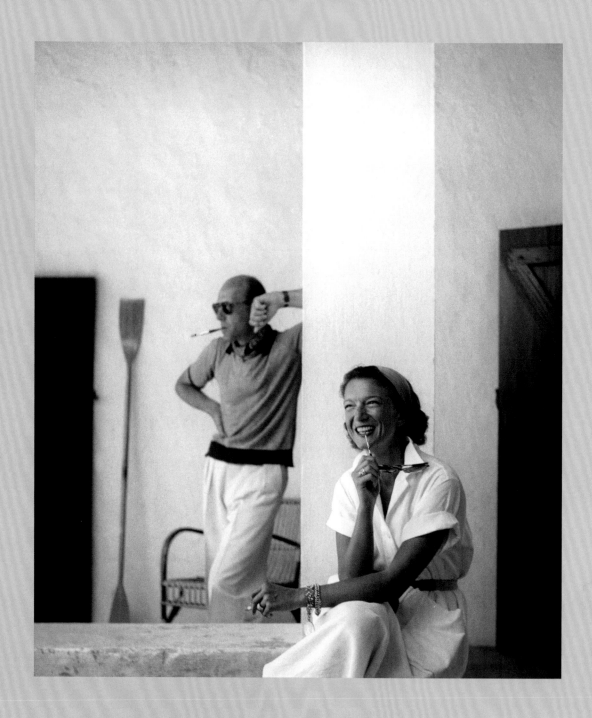

millicent fenwick (1910–1992) was an elegant heiress. she was born
in new york city to a pedigreed political family, studied under nobel laureate bertrand
russell, attended columbia and was fluent in french, italian and spanish.
she was a fashion model for *harper's bazaar*, a *vogue* editor for fourteen years and penned
vogue's book of etiquette. (the 650-page manual sold a million copies.) she was
elected to congress at age 64 circa 1974, was the lead sponsor of the resolution creating
the commission to monitor the 1975 helsinki accords on human
rights and appointed the first US ambassador to the UN food and agriculture
organization by president ronald reagan.

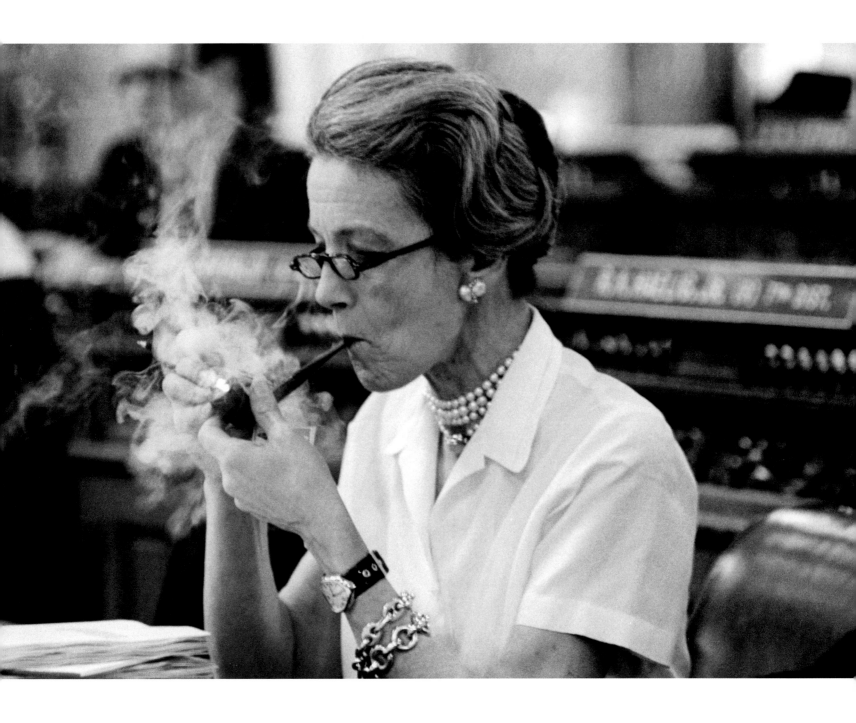

millicent fenwick never received a high school diploma or college degree. she got divorced in 1938. when her doctor said that cigarettes were bad for her, she took up the pipe. she championed consumer causes, women's rights and civil rights long before they were fashionable, along with peace in vietnam, prison reform, strip-mining controls, military program reductions, campaign spending limits and gun control. she was brutally honest and outspoken in her pursuits, often by way of *bon mots*. during a debate over equal rights for women, a male colleague announced: "i just don't like this amendment. i've always thought of women as kissable, cuddly and smelling good." her response? "that's the way i feel about men, too. i only hope for your sake that you haven't been disappointed as often as i have."

she's the exclamation point to every lively sentence.

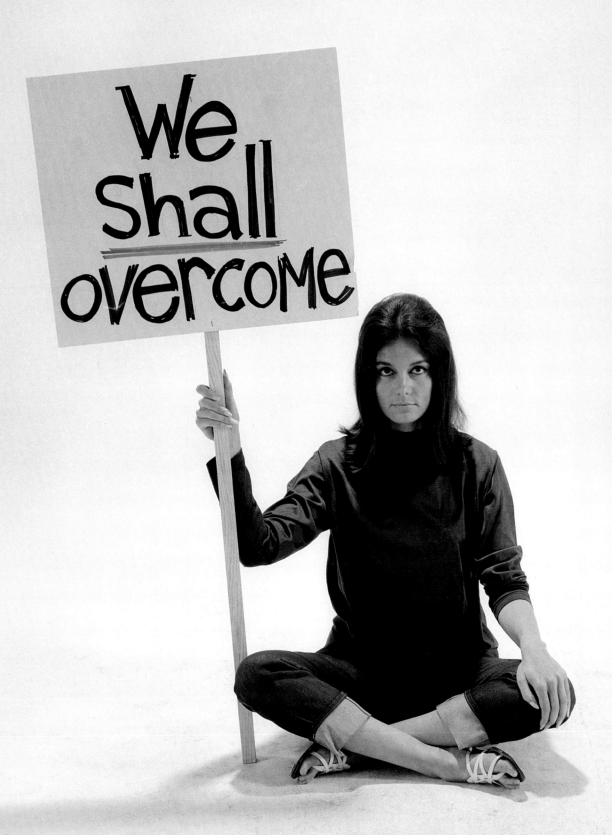

gloria steinem (1934–) spent her early childhood
reading books instead of going to school—her parents
were often traveling in a house trailer—and now she credits
this with missing some gender training. she helped to
change the consciousness of a generation about equality.
she's also a really (really) great listener.

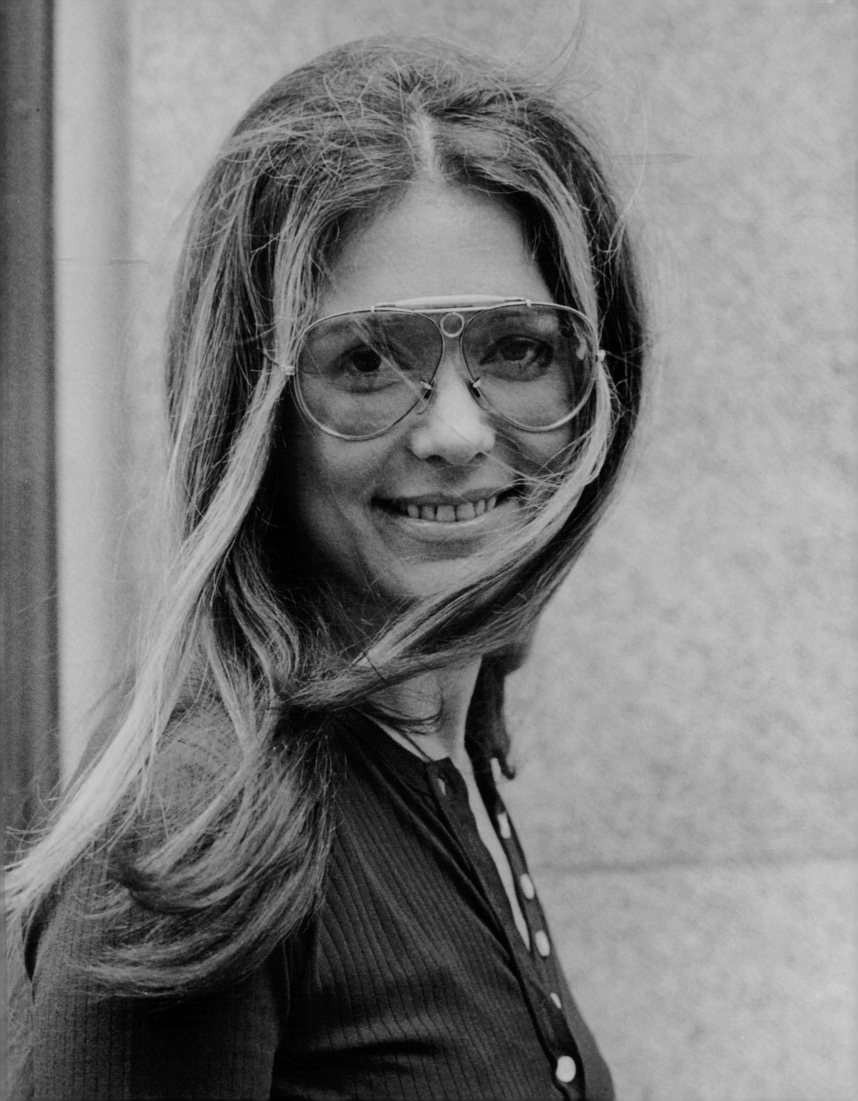

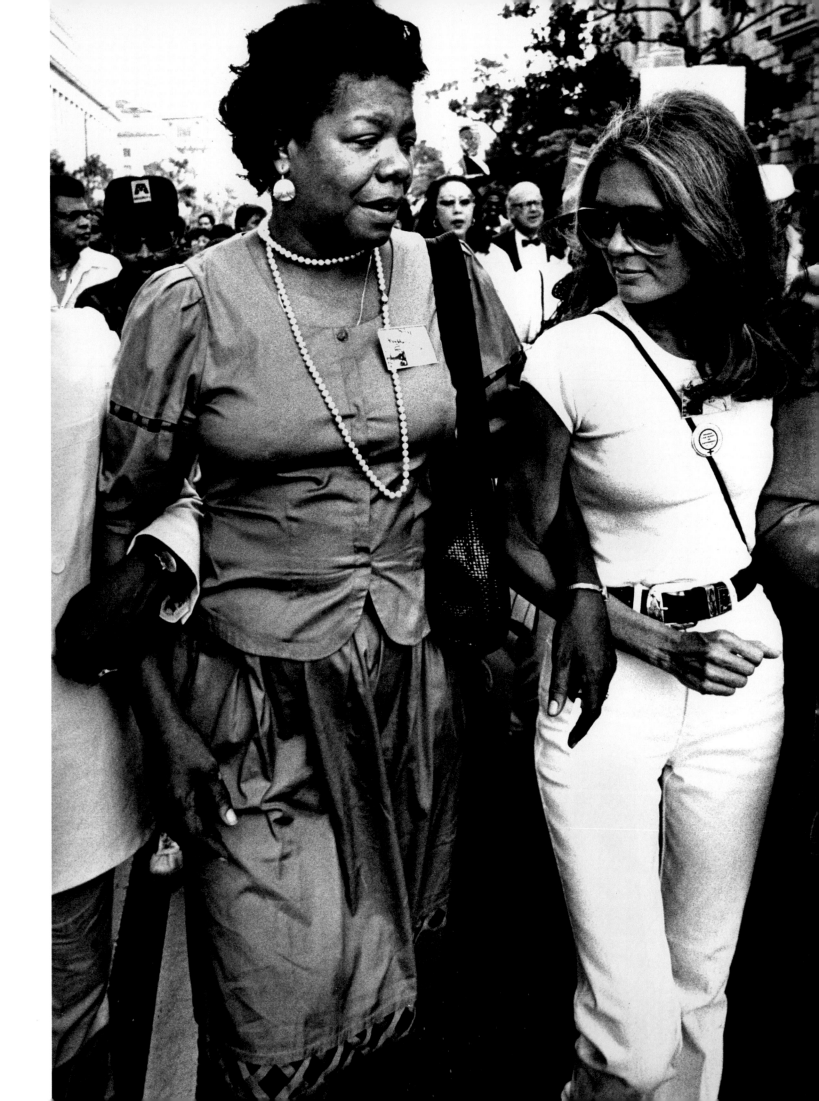

1957: travels to india on a student fellowship, stays for two years and embraces gandhi's idea that lasting social change comes from the ground up.

1960: arrives in new york city. writes for *esquire, life, glamour* and the *new york times magazine.*

1962: "the real danger of the contraceptive revolution may be the acceleration of woman's role-change without any corresponding change of man's attitude toward her role." *esquire* publishes gloria's feature about women choosing between a career and marriage a year before betty friedan releases *the feminine mystique.*

1963: attends the march on washington for jobs and freedom. she's close enough to hear gospel legend mahalia jackson urge martin luther king jr. to tell the crowd about "the dream," and his most famous oratory.

1964: follows the beatles around on their first new york visit. writes for *cosmopolitan* about the birth of beatlemania.

1968: helps legendary editor clay felker start *new york* magazine and becomes its political columnist and features writer. with her: tom wolfe, jimmy breslin and milton glaser.

1969: begins her "life as an active feminist" while covering an abortion speak-out for *new york.* "if i'm remembered at all," she reflected in 1981, "it will be for inventing a phrase like 'reproductive freedom'… it includes the freedom to have children or not to. … i think the revolutionary role of a writer is to make language that makes coalition possible, language that makes us see things in a new way."

1969:

"a feminist is anyone who recognizes the equality and full humanity of women and men."

1970: testifies before the US senate in support of the equal rights amendment. "i have been refused service in public restaurants, ordered out of public gathering places and turned away from apartment rentals. all for the clearly stated, sole reason that i am a woman." the ERA was introduced in 1923. congress passes it in 1972, but it falls three states short of ratification before the deadline nine years later.

1971: with brenda feigen fasteau and others, launches the women's action alliance, a center of information about starting childcare centers and domestic violence shelters. with congresswomen bella abzug and shirley chisholm, and civil rights leader dorothy height, founds the national women's political caucus. since the start of the NWPC, the number of female state legislators has increased from 363 to 1,800; congresswomen from 15 to 104; female mayors of major cities from 7 to 262.

1971: with co-founding editors, test-runs the preview issue of *ms.* magazine—the first national newsstand magazine to be created, owned and operated entirely by women—as an insert in *new york* magazine's year-end special issue. it sells 100,000 copies. (*new york*'s average in

1971: 40,000.) *ms.* officially launches as a national monthly magazine the following july.

1977: becomes a commissioner with bella abzug, patsy mink and shirley chisholm and others, and organizes a conference in every state and territory leading up to the national women's conference in houston. its purpose: to vote on issues that express what women in america want. two thousand official delegates from fifty states discuss and vote on twenty-six different planks, from child care to foreign policy, and are joined by thousands of observers from this and other countries. betty ford (R), who campaigned for the equal rights amendment and supported abortion rights, spoke; so did lady bird johnson (D) and rosalynn carter (D). "probably the most geographically, racially and economically representative body this nation has ever seen," gloria later notes. the NWC delivers a political agenda that includes equal employment, equal pay and full reproductive rights, and unifies a diverse nationwide women's movement.

1992: "the future depends entirely on what each of us does every day. after all, a movement is only people moving."

1993: as a board member of the ms. foundation for women, helps found take our daughters to work day. today, sons are welcome, too. it's the fourth thursday in april and is celebrated in countries around the globe.

2005: founds the women's media center, with actor and activist jane fonda and author robin morgan, to increase the coverage of diverse women's issues and the

number of women employed in and covered by the media.

2007: "i didn't change," she told a reporter when asked why she wed in 2000. "marriage changed. we spent thirty years in the united states changing the marriage laws. if i had married when i was supposed to get married, i would have lost my name, my legal residence, my credit rating, and many of my civil rights. that's not true anymore. it's possible to make an equal marriage."

2013:

honored with the presidential medal of freedom.

2015: "one of the simplest paths to deep change is for the less powerful to speak as much as they listen, and for the more powerful to listen as much as they speak."

2016: launches a documentary series with vice media, co-producer amy richards and a team of female journalists, called *woman.* it explores violence against women in countries from the americas to asia and africa. "more than poverty, natural resources, religion, or degree of democracy, violence against females is the most reliable predictor of whether a nation will be violent within itself or will use violence against another country," she explains. "…i have travelled the world as a writer and activist for my entire life. and i can tell you that by confronting the problems once marginalized as women's issues, we can tackle the greatest dangers of the 21st century."

to be continued…

she does
everything
she can
and
everything
she
"can't."

"sometimes, i feel discriminated against, but it does not make me angry. it merely astonishes me. how can any deny themselves the pleasure of my company? it's beyond me."

zora neale hurston (1891–1960) was a writer, folklorist and anthropologist. she was the auricular heart of the harlem renaissance. she liked hats, loved the theater and couldn't stand pretense. arriving at the after-party for a literary awards dinner brimming with artists and art patrons, black and white, on may 1, 1925, she bellowed two words she loved: "color struck!" it was the name of one of four works the literary newbie won an award for that night and her fifth eyebrow-raising, head-turning moment of the evening. she graduated barnard college at the age of 37. (her teacher: franz boas.) she spoke three languages. she made friends and conversation wherever her research led: while studying the customs, spirituals and dialects of the deep rural south (*mules and men,* 1935); lumber and railroad workers in florida labor camps; voodoo in new orleans and the bahamas (*tell my horse,* 1938). in return, she told groundbreaking stories saturated with the traditions of african-american culture and the poetry of speech. four novels, two books of folklore, an autobiography and fifty short stories, essays, articles and plays in thirty years to be exact. she was born in alabama in 1891. she believed everyone had a voice and a story to tell. "it's no use of talking," she wrote in her collected essays, "unless people understand what you say."

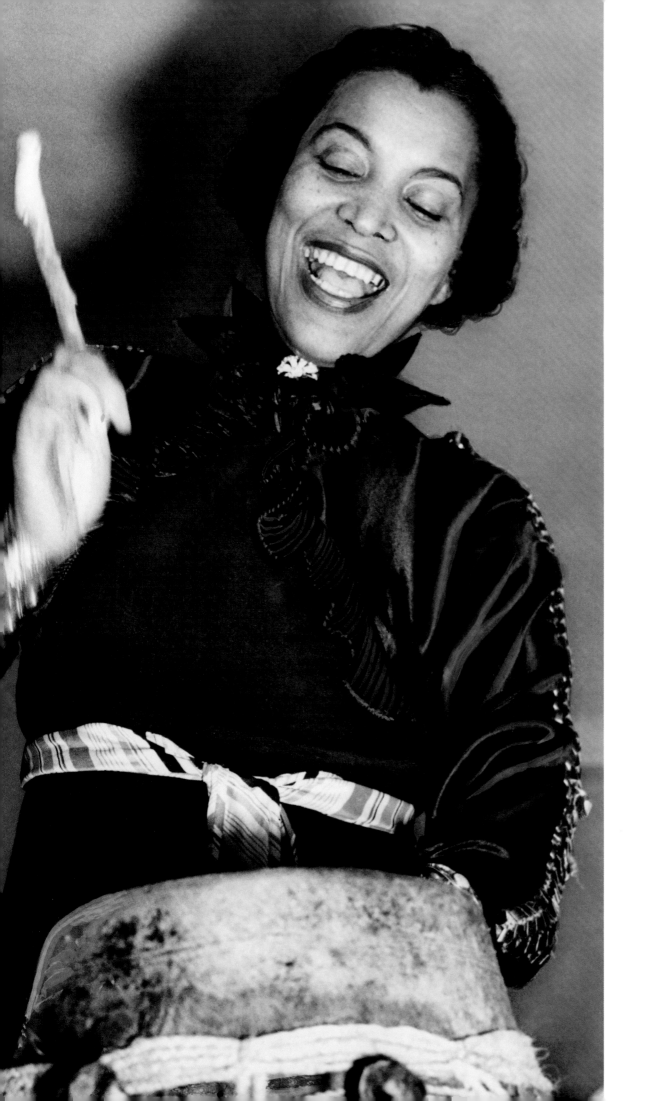

"i believe that any woman who
refuses to accept society's preconceived
notions of who or what they can
be is a feminist. i believe any woman who
is willing to struggle, strive—and if necessary learn
karate—to make their mark in the world
is a feminist. and, yes, i believe that any woman
who cares about her appearance, her star
billing and most especially her percentage
of the gross, is a feminist ●

moi

is all of these things."

miss piggy (1976–) is an international movie and television star, singer, bestselling author and,
of course, an icon of fashion, feminism and diva-dom. she enjoys speaking "franglais"
(a delightful custom-blend of french and english) and practicing karate whenever the mood strikes.

3.

she
prefers
rocking boats
to
safe bets.

"a lie to get out
of something, or take an
advantage for oneself,
that's one thing;
but a lie to make
life more interesting—
well, that's
entirely different."

diana vreeland (1903–1989) was america's style
director, a tastemaker who had an unfailing sense of the
next big thing. on paper, she was the fashion editor at
harper's bazaar (1936–1962), editor-in-chief of *vogue*
(1962–1971) and consultant to the costume institute
at the metropolitan museum of art (1971–1989), but what
she really did was help cast off the public's infatuation
with the status quo in favor of eccentric individuality
and a more bedazzled approach to living.

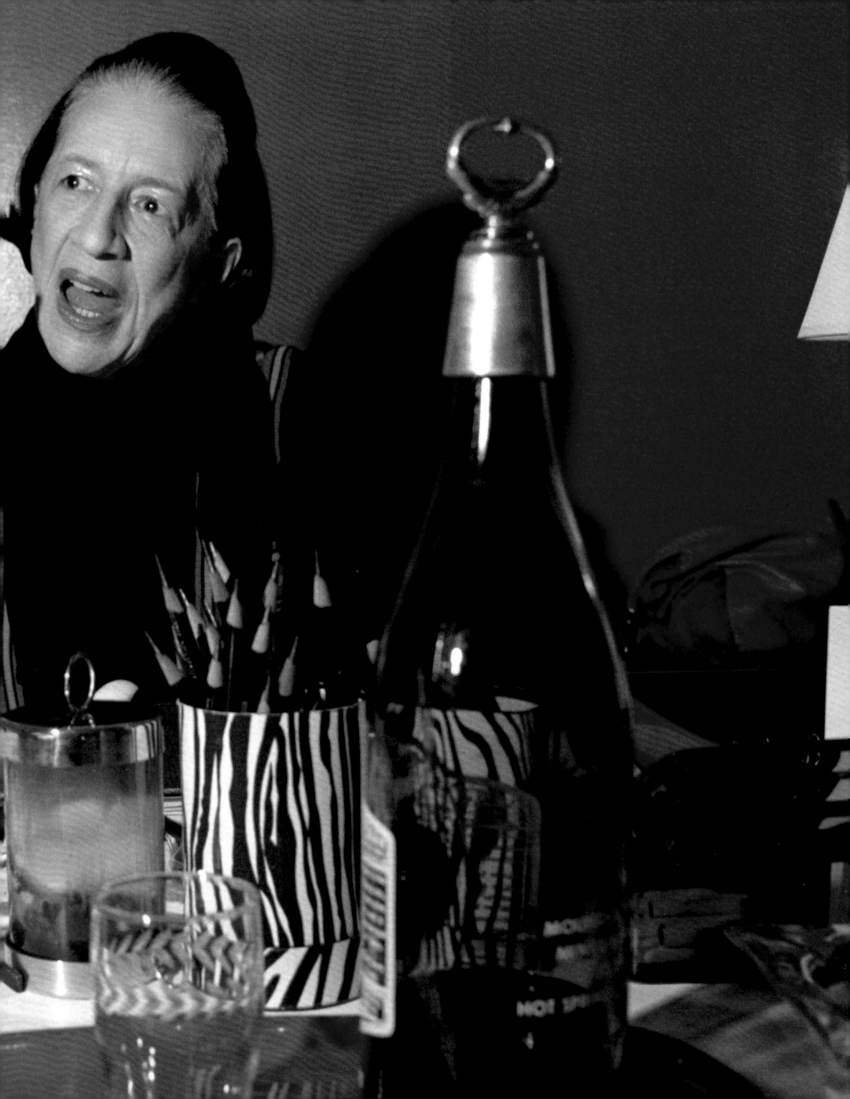

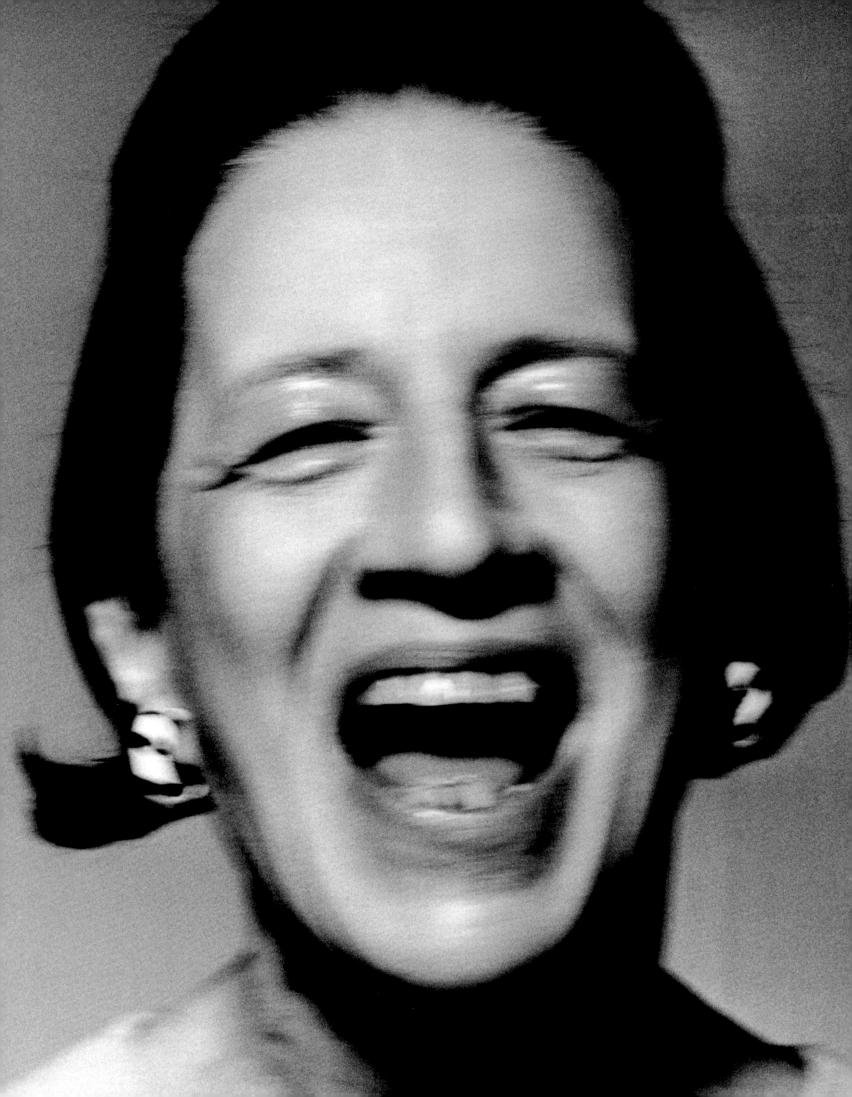

10

FEARLESSLY INAPPROPRIATE THINGS
DIANA VREELAND
MADE APPROPRIATE.

"when i arrived in america, i had these very **dark red nails**
which some people objected to, but then some people object to absolutely everything."

ballet slippers off stage. when the government rationed out food and clothing
coupons during world war II, she encouraged women across the nation to
purchase ballet slippers rather than cash in their coupons.

bikinis. diana first spotted one of these "swoonsuits" that exposed
"everything about a girl except her mother's maiden name" while in saint-tropez after WWII and
promptly ran a model wearing a green-and-white-polka-dot one in the may 1947
issue of *harper's bazaar.* "they" said it was shocking. she said, "it's that kind of thinking that
holds people back for thousands of years."

individuality. diana celebrated beauties in the pages and on the covers of *vogue*
seen as strange or exotic then but today considered timeless and iconic: twiggy, veruschka,
cher, penelope tree (whom she spotted at truman capote's black and white ball),
anjelica huston, lauren hutton, marisa berenson, edie sedgwick, barbra streisand. "if you've
got a long nose," she said. "hold it up and make it your trademark."

andy warhol.

fashion + **art** + **music** + **society.** to diana, it all intersected and *vogue,* during
her reign, made a radical shift to reflect that.

thong sandals. she had hers recreated from a pair that had been perfectly
preserved by the ashes of mount vesuvius near naples and wore them with cigarette
pants on the streets of new york.

being an **enthusiast of health and fitness, skin care, hair treatments
and even plastic surgery**. she filled *vogue* with articles on these topics long before
they became popular obsessions.

the high-low mix. aristocracy & pop culture. traditional eloquence
& street jargon. an expensive handbag & cheap and cheerful earrings. diana ran in society
circles but she wasn't from it, which gave her a unique perspective.

fashion as art. her shows at the MET museum's costume institute were
purposefully inaccurate. (which, as you can imagine, miffed historians.) she embellished
and she mixed eras. it was the *feeling* fashion evoked that interested her,
not facts. her shows were extended and millions flocked. and the MET gala became
a really big deal. (so, fashion as entertainment, too.)

she writes her own rules and inspires others to follow them.

"one of the artistic directors of
a company said they had to adhere to the
aesthetics of a culturally european
picture of ballet. we said we want ballet
to look like america."

joan myers brown (1931–) is a dancer, choreographer
and artistic director from philadelphia who performed and toured
with sammy davis jr., fats domino, cab calloway's cotton club revue
and pearl bailey, and received the national medal of arts in 2013.
she fell in love with ballet in the 1940s but couldn't find a school
to accept her. "black ballerina" was an oxymoron. so in 1960,
four years before the civil rights act, she founded the philadelphia
school of dance arts to give students the opportunity she didn't
have. in 1970, when there still weren't performing opportunities
for african-american youth in the city, she created them. for
fifty-eight years, she's admitted students regardless of their ability
to pay and turned them into professional dancers around the
world, and her ballet-based modern dance company, philadanco!,
tours the globe showcasing the innovation and creative spirit of
mainly african-american dance traditions with a multicultural
mix of dancers and choreographers.

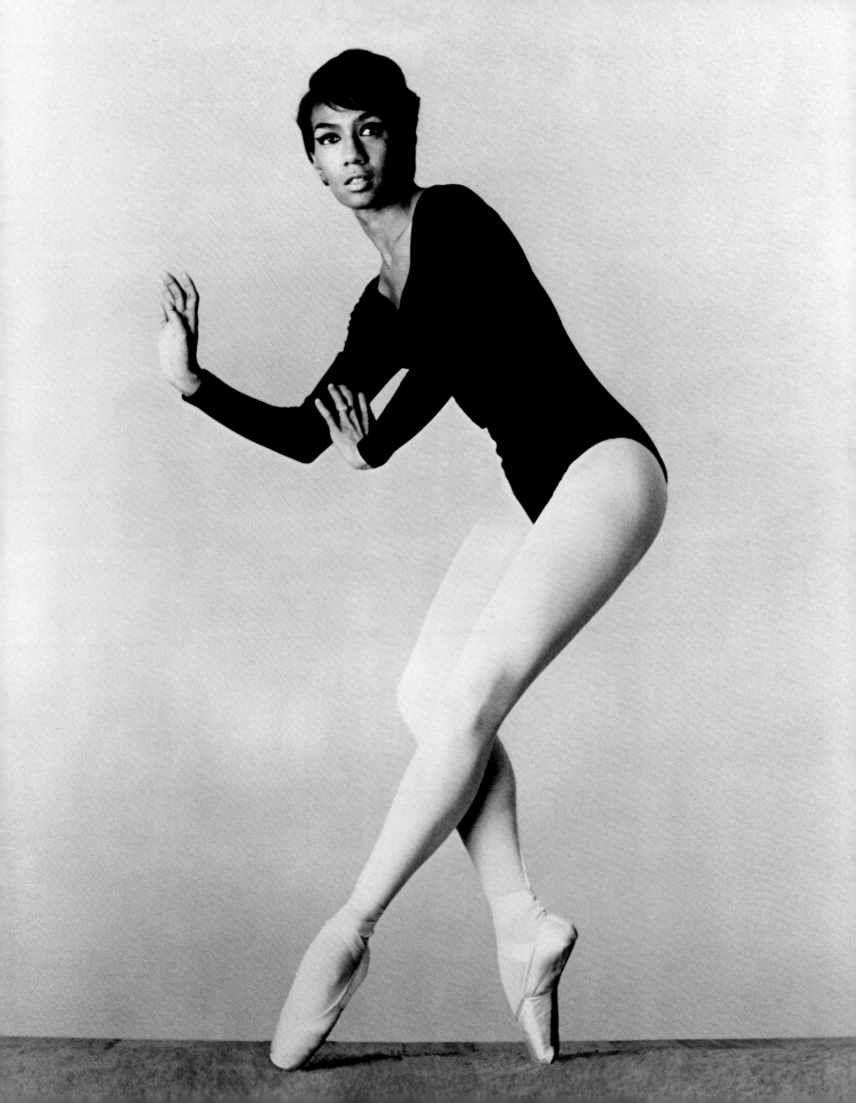

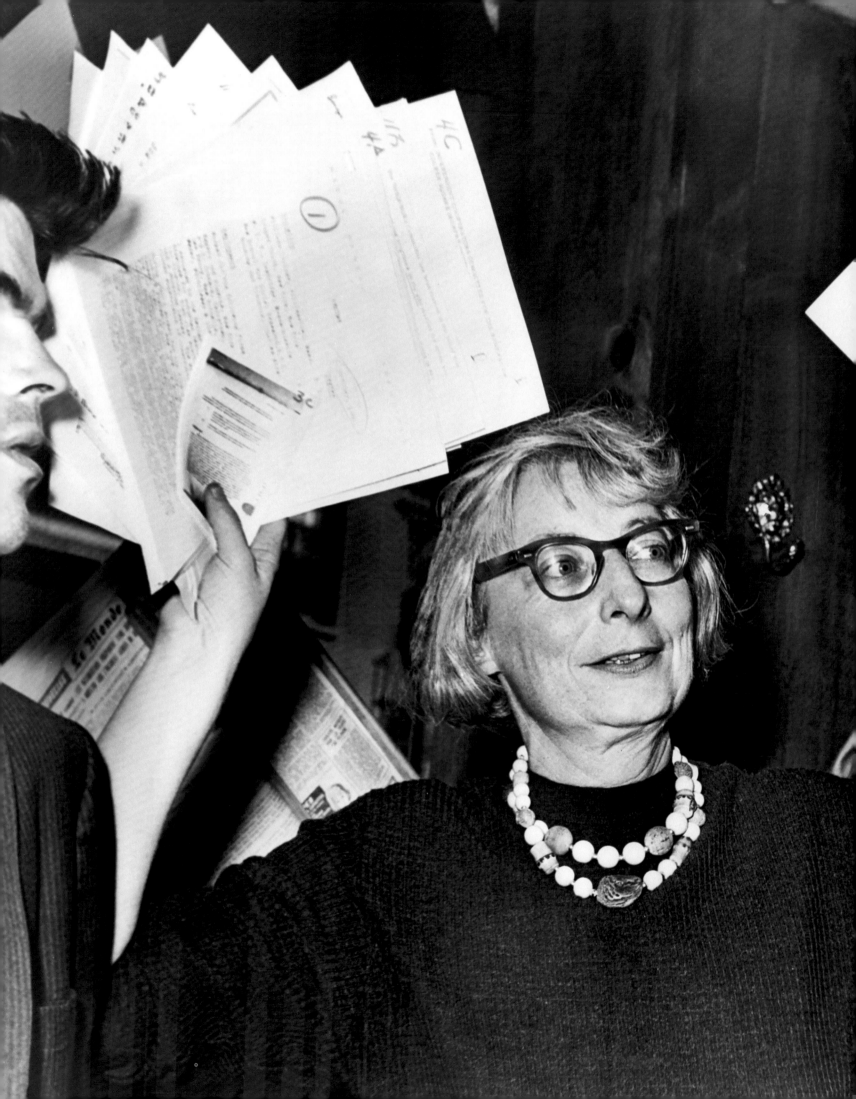

jane jacobs (1916–2006) lived above a candy store in the west village and was a grassroots advocate for protecting neighborhoods against one-size-fits-all urban development. her 1961 book, *the death and life of great american cities*, is one of the most influential books in the history of american city planning. she wrote about what made neighborhoods interesting and safe. she proposed radically new ideas for rebuilding cities based on personal observations—like "mixed use" developments and bottom-up planning—that totally contradicted what actual urban planners recommended. most famously, she challenged developer robert moses, and she won. her critics called her a "militant dame" and "housewife" and her ideas "small-scale." and yet she stopped washington square park and parts of soho and little italy from being destroyed for moses's six-lane LOMEX expressway in 1968. (thank you, jane.) today the impact of her work is seen around the world, from melbourne, australia to vancouver, canada.

almost every big city is getting
ready to build…they will be spacious, parklike,
and uncrowded. they will feature long
green vistas. they will be stable and symmetrical
and orderly. they will be clean, impressive
and monumental. they will have all the attributes
of a well-kept, dignified cemetery. …

…it is more to the point to consider what makes a city center magnetic, what can inject the gaiety, the wonder, the cheerful hurly-burly that makes people want to come into the city and to linger there.

—*"downtown is for the people" by jane jacobs, 1958*

she is fearlessly clever and cleverly fearless.

"my head is not in the sand.
but my thing is, if i can't work with you,
i will work around you."

annie easley (1933–2011) read a story in a newspaper
about twin sisters working as "human computers" at cleveland's
aircraft engine research laboratory (later the NASA glenn
research center) in 1955 and applied to be one the next day.
she got it—and for the next thirty-four years she developed and
implemented computer code that changed how we live today.
she found alternative systems to solve energy problems—
including the battery technology used for early hybrid vehicles.
she led software development for the world's first high-energy
rocket stage, centaur, fueling the launch of NASA space shuttles
and communication, military and weather satellites. growing
up in jim crow alabama, her mother told her "you can be anything
you want to be, but you have to work at it." she graduated
valedictorian. she helped other african-americans prepare for
the literacy test required of them in order to vote. she tutored
school children and, through NASA's speaker's bureau,
encouraged young women and minorities to pursue careers
in science, technology and math. she earned a degree in
mathematics while working full-time. she was a founding member
of NASA's ski club. in the 1970s she helped mediate gender,
race and age discrimination complaints at work as an equal
employment counselor. she and a coworker were also the first
ladies in the office to wear pantsuits. (it caused quite a
liberating stir.)

"don't forget to take your pill."

[simultaneously] "i won't."

mary richards (*the mary tyler moore show*, 1970–1977)
was the first independent, single working woman on television,
which made her wildly progressive from the start. then in
1972, the year the pill became legal in the US for unmarried
women, audiences learned mary was on birth control when
her parents came for a visit; her mother called out to her father
"don't forget to take your pill!" and both dad and daughter
replied, "i won't!" her subtle on-screen admissions broke timely
new ground in a fast-changing era of women's liberation.

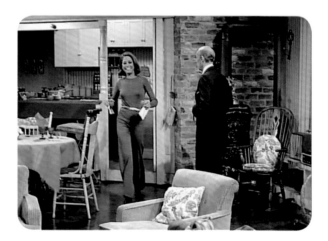

"well, dad! this is terrific getting to
spend an evening with you."

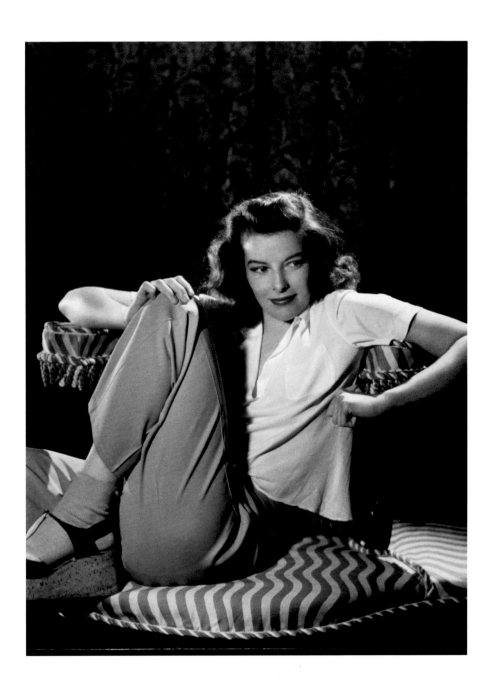

katharine hepburn (1907–2003) once walked around a
studio lot in her underwear until the costume department returned
her trousers, rather than wear a dress. she chose roles in female-
led films and turned smart, middle-aged characters into
headstrong, funny, sexy leaders (see: *desk set*, *the african queen*).
she dated howard hughes, had a twenty-seven-year love affair
with spencer tracy, orchestrated her own career comeback by
buying the film rights to *the philadelphia story* and selling them
to the movie studio with her as its star, presented at the 1974
oscars in gardening clothes and clogs, and loved brownies
made with only a smidge of flour. (a smidge!) she was an actress
who refused to play a traditional role—on-screen or off—and
redefined femininity in the golden age of hollywood because of it.

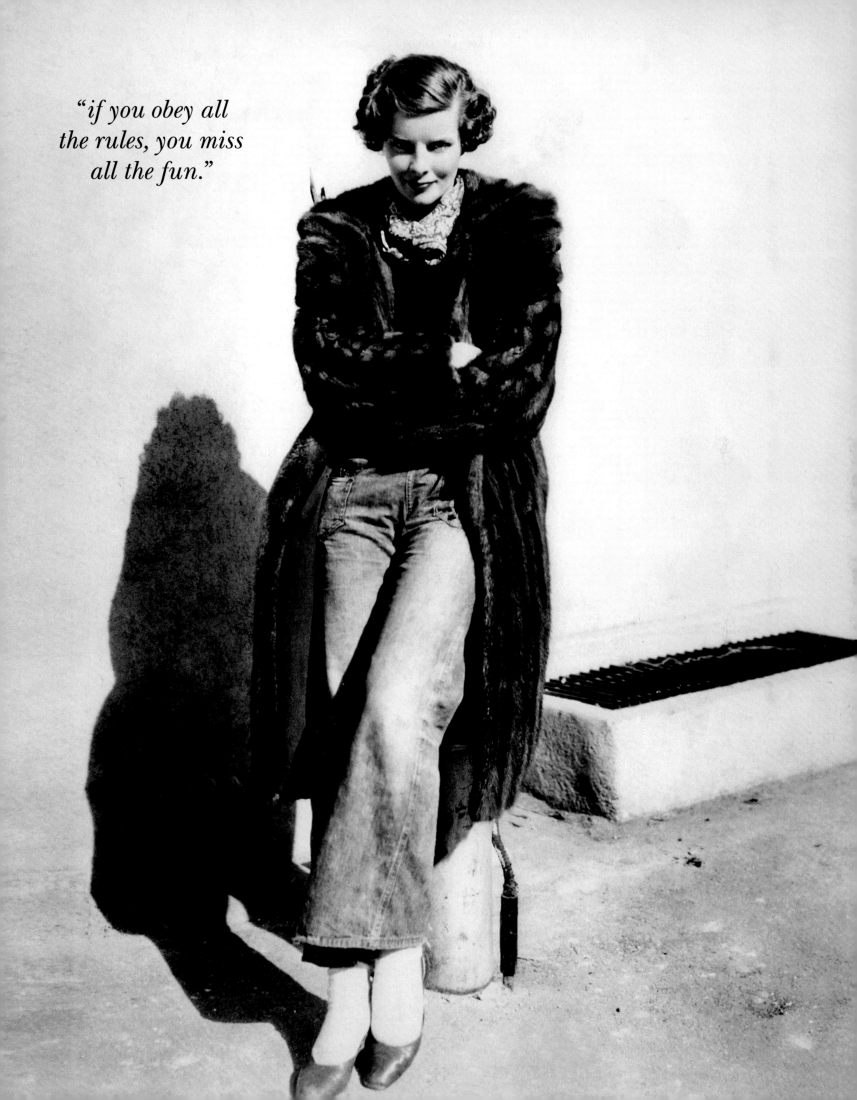

"if you obey all the rules, you miss all the fun."

she
says when
in
doubt
take it up
a notch.

iris apfel (1921–) used to cut class in astoria, queens every thursday afternoon when she was 11 to explore manhattan. she haggled her first vintage find—a sixty-five-cent brooch—in greenwich village on one of those outings. she was an assistant illustrator to robert goodman, a writer for *women's wear daily* and by her 30s, was criss-crossing the globe through european flea markets and souks in north africa collecting artisanal clothes, furniture and fabrics for her burgeoning interior design business. when 17th-, 18th-, 19th- and early 20th-century fabric supplies dwindled, she co-founded old world weavers with her husband to replicate them, using specialist looms and craftspeople all over the world. greta garbo, estée lauder and faye dunaway were her clients; as was the metropolitan museum of art and the white house. (she did historic restorations for nine administrations.) now in her 90s, she's a visiting professor at the university of texas. "i always feel like a big sponge, i feel like i learn lots of things by osmosis, and i feel that i'm always absorbing. i mean, when people say, 'what is your inspiration?' i could throw up. i mean, i'm inspired by the fact i get up in the morning. and i'm still here."

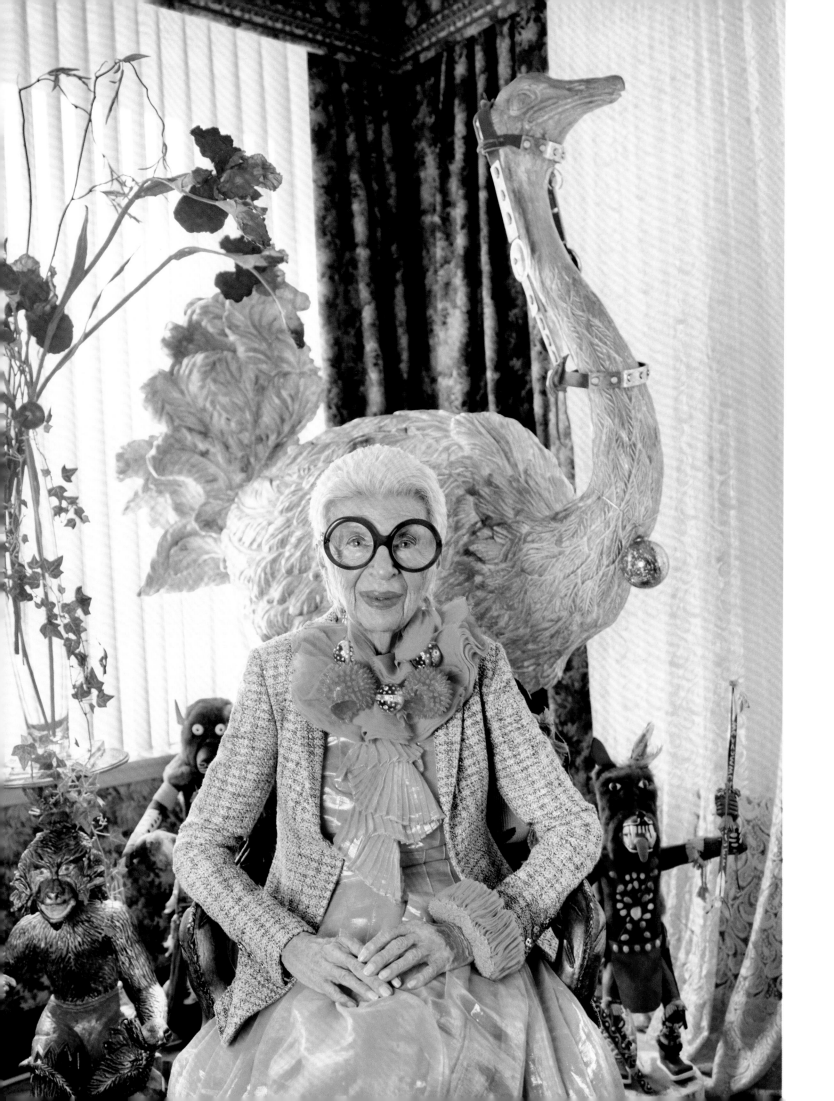

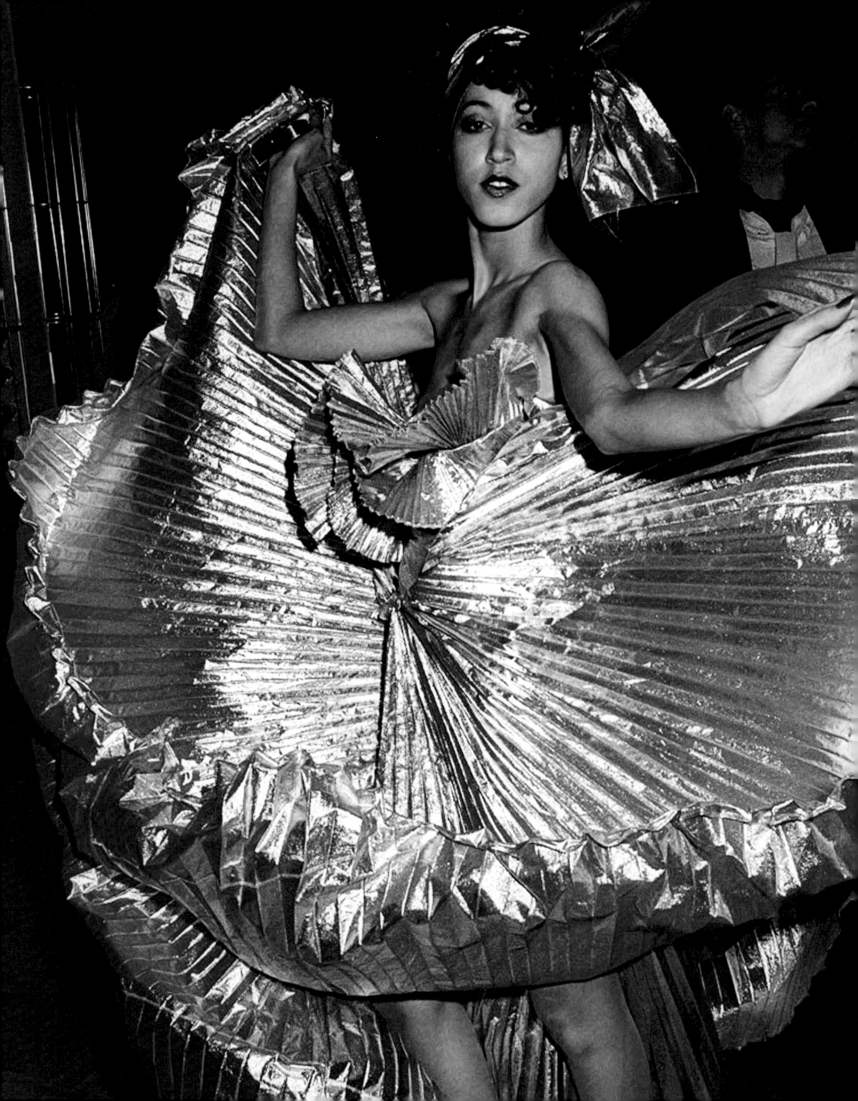

"i'm always in love."

pat cleveland (1950–) didn't just walk catwalks in the 1970s. she revolutionized them, dancing, twirling and strutting her way through shows in new york, paris and milan with an energy and *joie de vivre* that broke the industry's stuffy mold. with it, she became fashion's first black supermodel, a halstonette and a fixture at studio 54—but not before moving from new york to paris as a statement against america's racism and vowing to stay there till a black woman appeared on the cover of *vogue*. (it was to be beverly johnson, august 1974, and pat moved back right after.) there, she modeled by day for valentino, yves saint laurent, thierry mugler and artist salvador dalí and partied by night. she was karl lagerfeld's house model for chloé and she electrified the historic battle of versailles fashion show in 1973, a friendly face-off that pitted five french designers against five american designers—and their collective of status-quo-changing black models—that ushered in new public definitions of beauty and individuality.

she's no phony but doesn't mind if her jewels are.

elizabeth taylor (1932–2011) went from being a child
actor to "the greatest movie star of all." she arrived in rome for the
filming of *cleopatra* with one husband, three children, five dogs,
two cats, multiple secretaries and dozens of attendants. she played
complex, emotionally-charged characters in over fifty films—
from one half of a manipulative marriage (*who's afraid of virginia
woolf?*) to a tantalizingly powerful pharaoh (*cleopatra*) and a
tempestuous wife (*cat on a hot tin roof*). she married eight times.
twice to richard burton. she loved big diamonds. in response to
robert kennedy's assassination in 1968, she took out a full
page ad in the *new york times* demanding gun control and got one
hundred other celebrities to sign it. (president johnson signed
the gun control act into law later that year.) she was one of the first
public voices to speak up about the AIDS crisis and raised
hundreds of millions for research, treatment and care through
amfAR, which she cofounded, AIDS project los angeles and the
elizabeth taylor AIDS foundation. she established medical
centers in LA and DC. she testified before the senate and congress
for the ryan white care act three times before it was enacted in
1990. "any home where there is love constitutes a family," she once
said. "and all families should have the same legal rights. ...
during my life, i've seen many things good and bad. but the bad
things never came out of loving acts, loving gestures or
loving relationships. ...long live love."

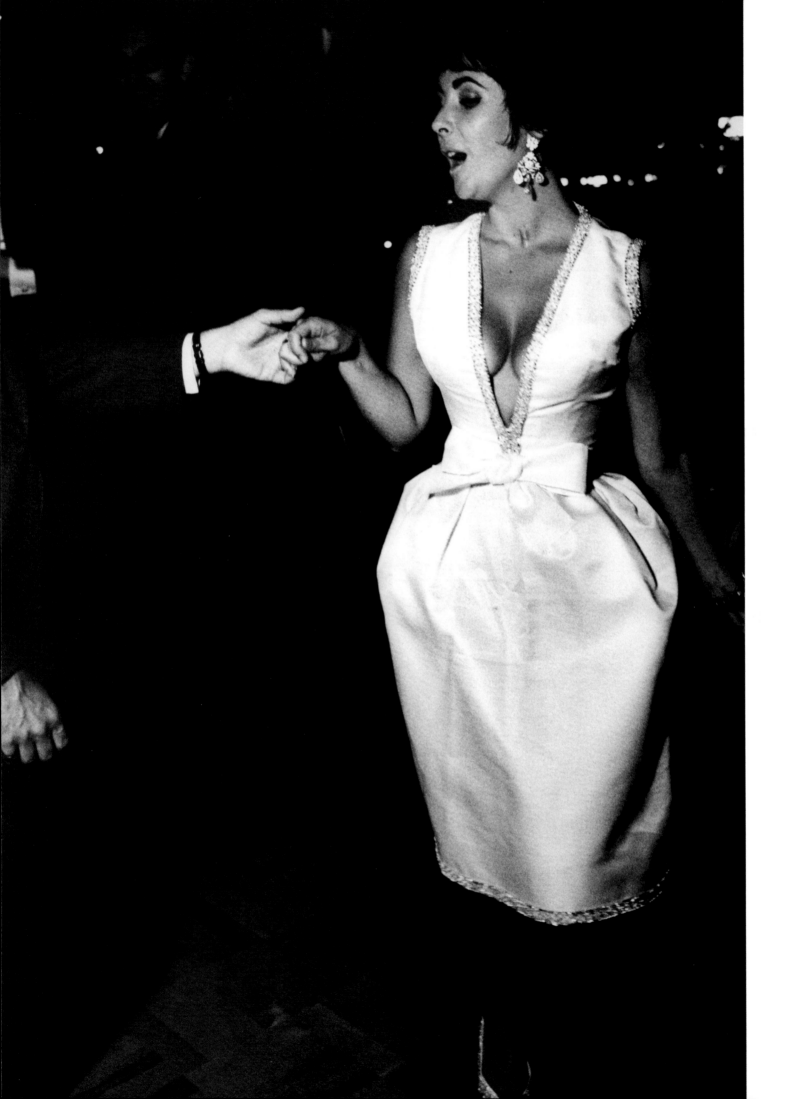

"you cannot
have passion of
any kind
unless you have
compassion."

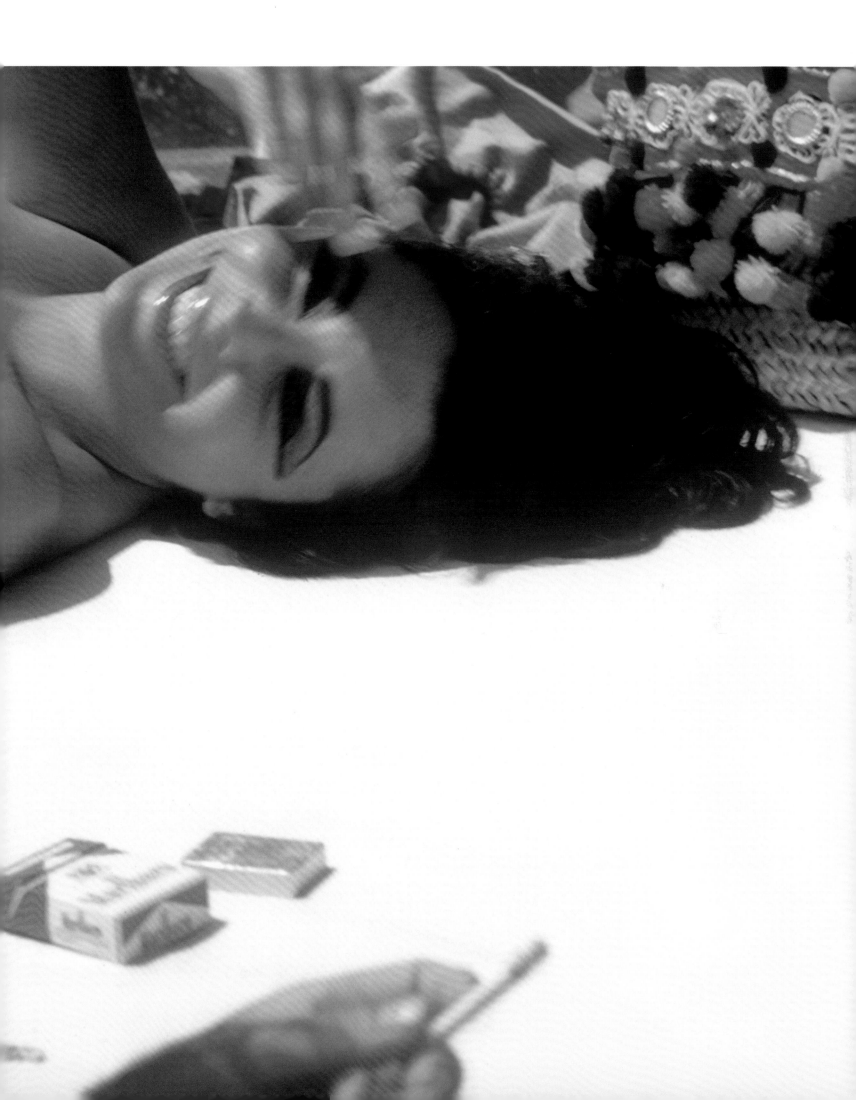

she welcomes wild guesses.

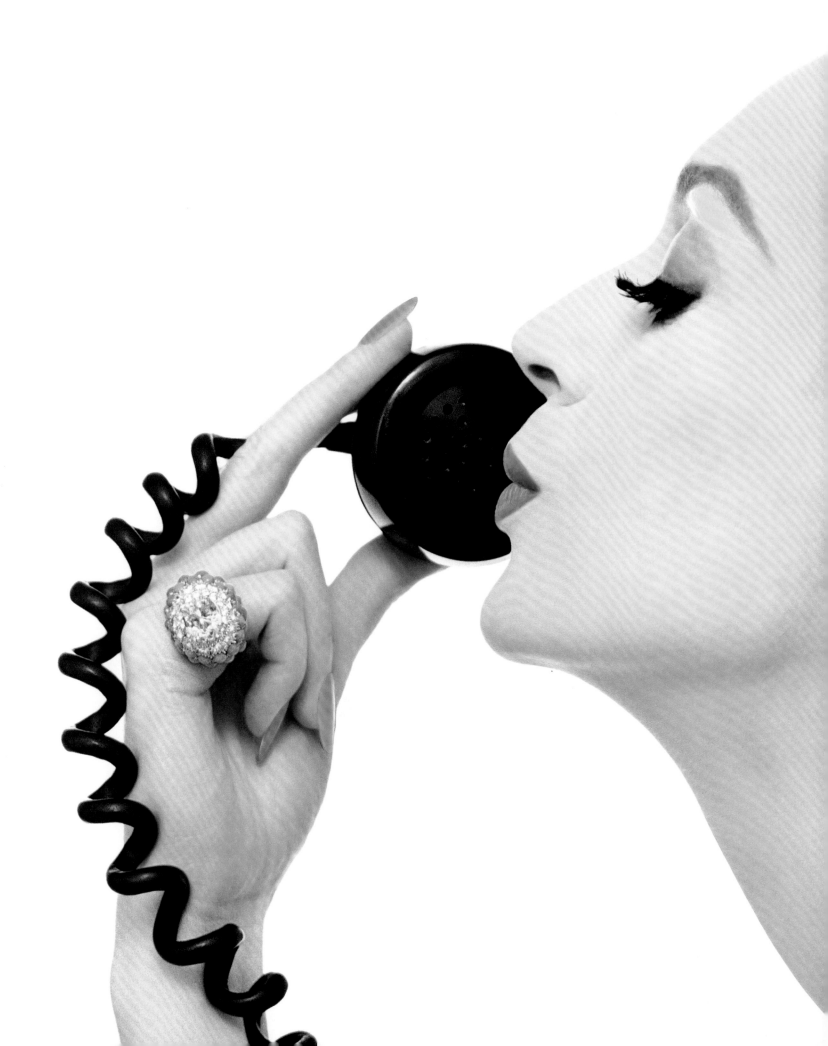

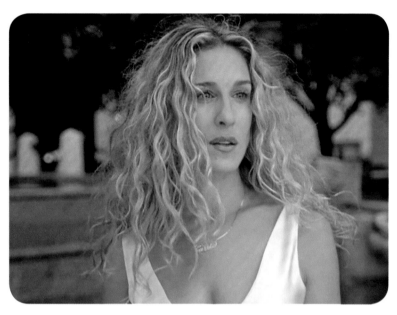

"maybe some women aren't
meant to be tamed."

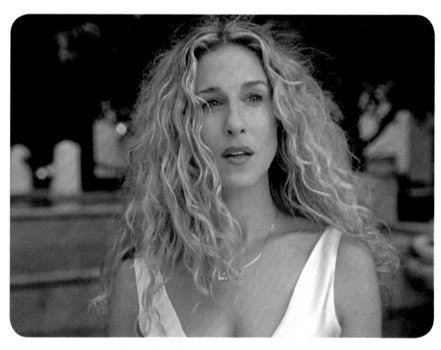

"maybe they need to run free
until they find someone…"

carrie bradshaw (*sex and the city*, 1998–2004) was
a single new yorker on a quest to find herself, where she fit
in and who she fit with. along the way she turned those
adventures into a column and a book; she wrote for *vogue*.
she went to ballgames in fur coats. she said "i'm sorry"
in french, in costume and with *le fillet de fish*. she spent
$40,000 on shoes. she over-analyzed relationships and
asked existential questions over brunch, such as "but if you
love someone and breakup, where does the love go?" she
moved (temporarily) to paris. through all her surreal
moments, what prevailed were her three best girlfriends
and the power of sisterhood.

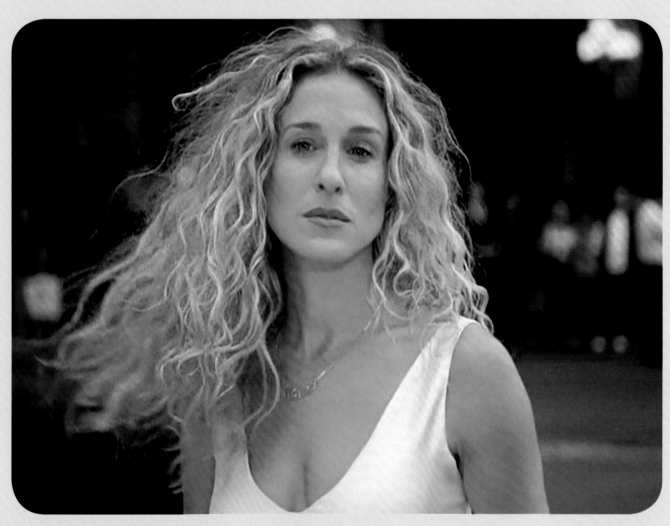

"… just as wild to run with."

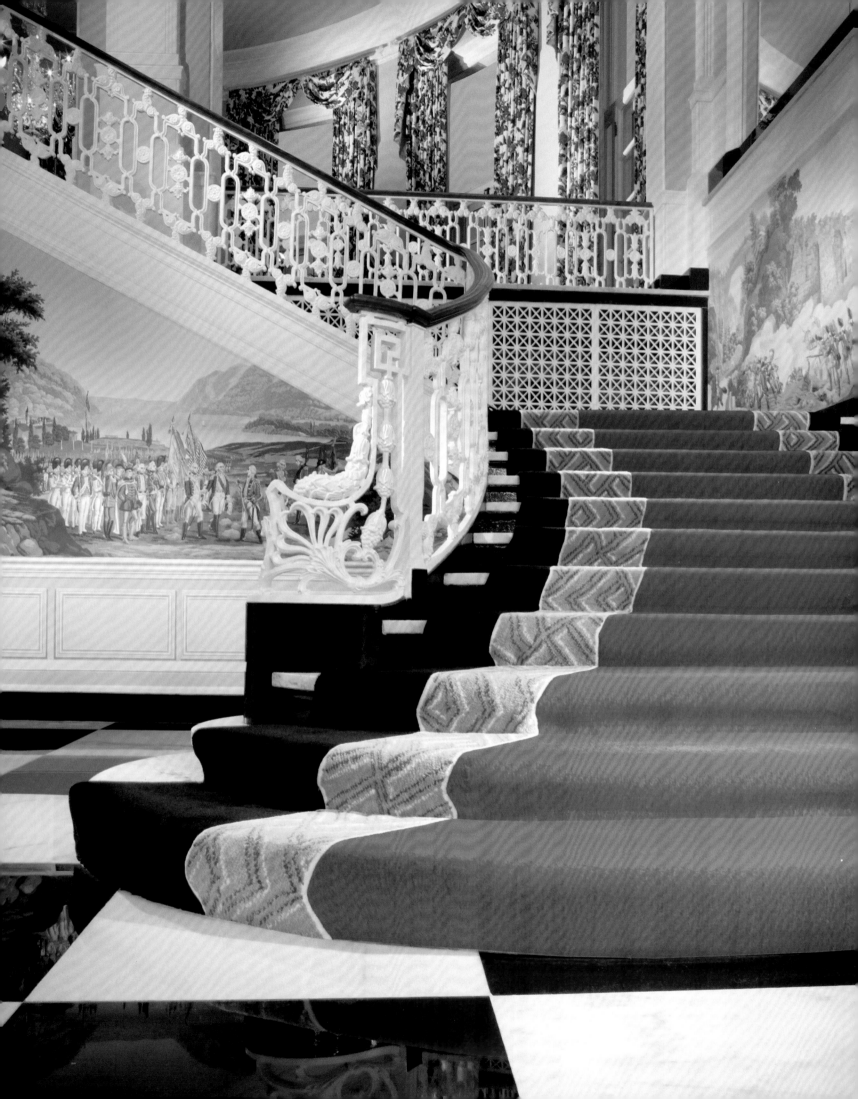

dorothy draper (1889–1969) opened america's first interior design business in 1925 and zhoozhed a drab and dreary world into cheerful technicolor. (ninety-two years later the company is still going bold.) she "draperized" hotels across the country like the greenbrier, essex house and the carlyle with vibrant hues, outrageously wide stripes, playful details and art deco and rococo touches. she created one of manhattan's chicest streets, sutton place, by painting a block of former tenement houses black with white trim and audaciously colored doors. in the 1950s, she helped a ballooning middle class decorate their homes as beacons of individuality: she wrote bold books that make decorating liberating and fun. (one of our favorite tips: "if it looks right, it is right.") she answered their questions in an advice column, *ask dorothy draper,* that ran in seventy newspapers, three times a week. she designed fabrics and furniture. she proposed using sliding glass doors instead of shower curtains. she was *good housekeeping*'s design director. she was as glamorous as the rooms she decorated—often wearing long capes, headpieces and white gloves on her six-foot frame—and she grew up in a town in upstate new york brilliantly named tuxedo park. she believed "the color of your front door announces your personality to the world." (she liked cherry red.)

she believes more is more
and less is a bore.

lillian bassman (1917–2012) became an artist's model
in her late teens because she hated babysitting. she studied
textile design and painting, doing murals for the works progress
administration during the great depression, until she took a
graphic design class alexey brodovitch was teaching at the new
school. she became his assistant at *harper's bazaar*. then, in 1945,
art director of the magazine's spin-off, *junior bazaar*, where she
collaborated with photographers like richard avedon and louis
faurer. within a year, she was shooting pictures. as one of the
first female fashion photographers, she made pictures unlike
anyone else: dreamy black-and-white images that she manipulated
in the darkroom with tissue, gauze, bleach and more to make
grainy, blurry and painterly. her women were equal parts strong
and fragile, and to capture the natural grace she wanted, she
sometimes photographed them on closed sets. men were not
allowed. she flipped the switch on undergarment advertising and
replaced the industry's pharmaceutical aesthetic (translation:
images of women constrained by "equipment") with the organic
glamour of fashion models lingering in lingerie. she was married
for seventy-three years. (they met when she was 6, he 9; at 15 they
moved in together; three years later they were married.) she made
her own clothes. she loved spending weekends at the metropolitan
museum of art near her apartment on new york's upper east
side. she was inspired by dance and el greco portraiture. at age 87,
she picked up photoshop and reworked her photos from the
1940s, '50s and '60s to create brand-new images. she once bought
a white fridge and then painted it a different shade of white.
she could alter just about anything to suit her taste.

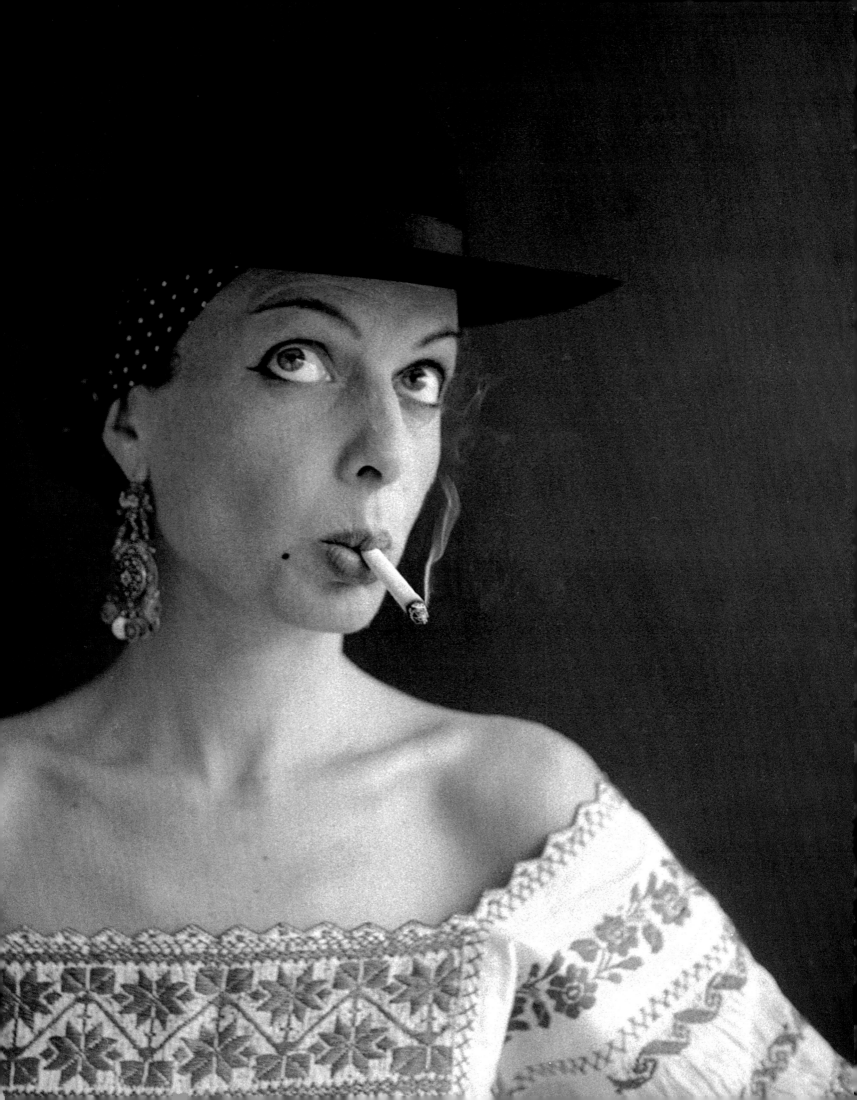

"in running the carpet sweeper, putting up her hair or looking out of a window, there is grace, but it usually passes unnoticed in everyday life. i try to record that natural grace with the camera."

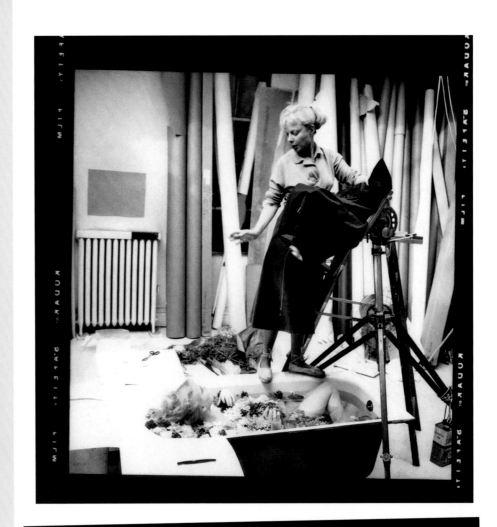

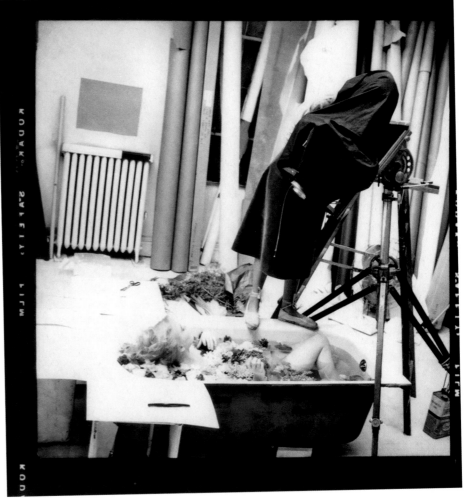

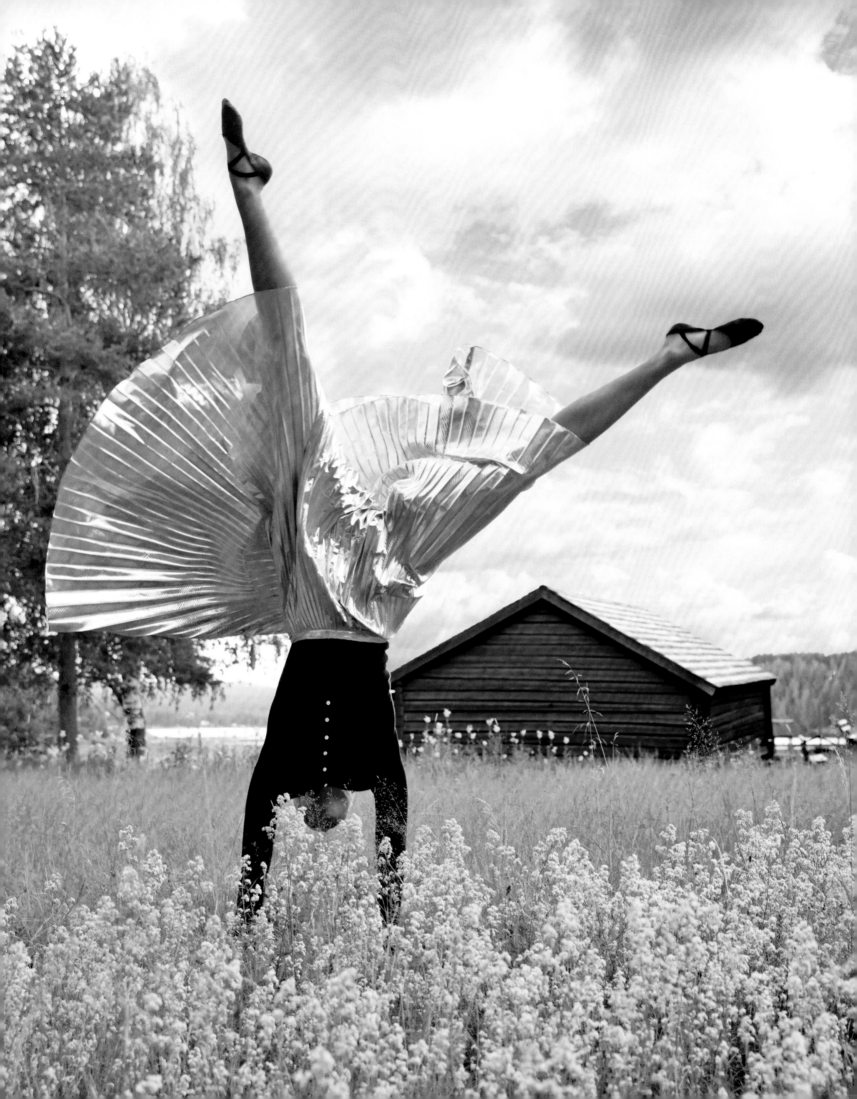

5.

she
opens doors
and
hearts.

joan didion (1934–) has spent over half a century examining the cultural values and experiences of american life and putting pen to paper. as an editor for *vogue*, she chronicled "self respect: its source, its power" as second-wave feminism blossomed. the spring before the summer of love, she traveled to san francisco and immersed herself with hippies, runaways and acidheads in haight-ashbury, investigating america's counterculture as a symptom of "social hemorrhaging" that would become *slouching towards bethlehem*. she began writing for the *new york review of books* in 1973—about movies, at first, but then politics, and traveled through north and central america. *salvador* (1983), about el salvador's civil war, and *miami* (1987), about the city's social and political turmoil, are based on essays she wrote there. she examined the headline-making booms and busts of the 1970s in cities from washington DC to los angeles for the essays in *after henry* (1983). and that's just the beginning. she's inspired by henry james and ernest hemingway. she writes journalism that reads like novels. (she's written five of those, too.) "i write entirely to find out what i'm thinking, what i'm looking at, what i see and what it means. what i want and what i fear," she wrote in 1976 of her motivation. she writes in order to understand, and helps us to understand, too.

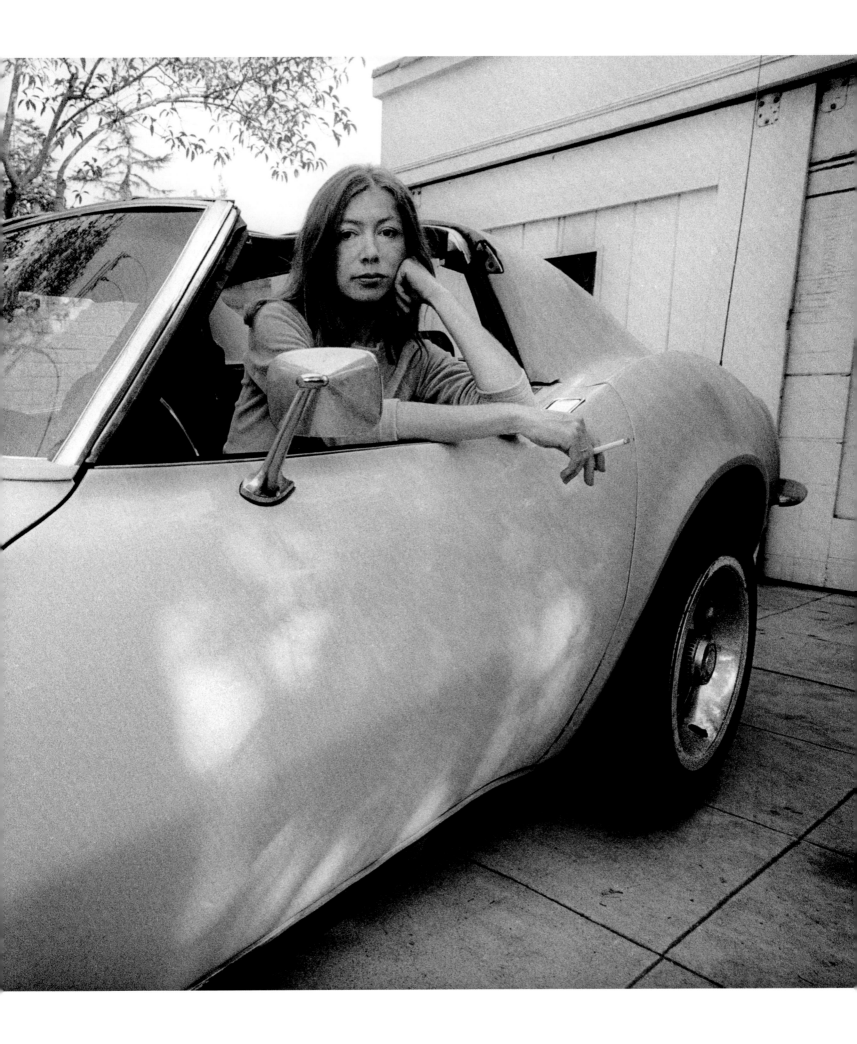

it was once suggested to me that, as an antidote to crying,
i put my head in a paper bag. as it happens, there is a
sound physiological reason, something to do with oxygen, for doing
exactly that, but the psychological effect alone is incalculable:
it is difficult in the extreme to continue fancying oneself cathy in
wuthering heights with one's head in a food fair bag.

—*"on self respect,"* slouching towards bethlehem *by joan didion*

above all, she is the girl who "feels" things, who has
hung on to the freshness and pain of adolescence, the girl ever
wounded, ever young. now, at an age when the wounds
begin to heal whether one wants them to or not, joan baez
rarely leaves the carmel valley.

—*"where the kissing never stops,"* slouching towards bethlehem *by joan didion*

nancy kwan (1939–) grew up in hong kong and studied
dance at the royal ballet school in london. with no experience,
she outshown five hundred actresses for the lead role in a
hollywood film—the first for someone of asian ancestry—
and won a golden globe for her performance. she sparked a craze
for bobbed hair when vidal sassoon cut her hair into "the kwan"
in 1960; bruce lee turned her dance moves into a choreographed
fight scene for a spy film. she followed it up with *flower drum
song*, the first western film with an all-asian cast, paving the way
for others and over fifty films of her own.

mary wells (1928–) has created some of the most iconic images and sentiments in the history of advertising. she began as a copywriter in the 1950s at a department store in her hometown of youngstown, ohio, and jumped into agency life on madison avenue at mccann erickson in new york. she took risks in work and life, and when it came to advertising, believed in the theatrical and the dramatic. she coined "plop, plop, fizz, fizz" for a certain antacid. outfitting braniff's stewardesses in printed pucci and commissioning artist alexander calder to paint their fleet of planes in pastels in the 1960s was her head-turning "end of the plain plane" idea. (it turned braniff into the airline of the jet set.) when she walked out of one agency and opened her own, wells rich greene, in 1967, she became the first female CEO of a company on the new york stock exchange (and at one point the highest-paid executive in the industry). she helped save american motors corporation from bankruptcy with the first-ever automobile comparison ads—and by helping redesign its cars. she resurrected manhattan's image with "i love new york." she's lived and worked in new york, dallas, london, the french riviera, mexico and brazil. with a bevy of audacious friends—joni evans, lesley stahl, joan juliet buck, candice bergen, lily tomlin, marlo thomas and liz smith included—she launched the website wowOwow (for "women on the web") as a platform for conversation between them and women around the world. and in 2010, she helped launch the lifestyle site purewow to elevate women's everyday on national and local levels. "you have to read books on subjects you know nothing about," she said about being successful. "you have to travel to places you never thought of traveling. you have to meet every kind of person and endlessly stretch what you know." it's good life advice, too.

"if you're not satisfied with your life, it's time to invent a new one."

—*mary wells*

she won't be boxed
in but always
has great people in
her corner.

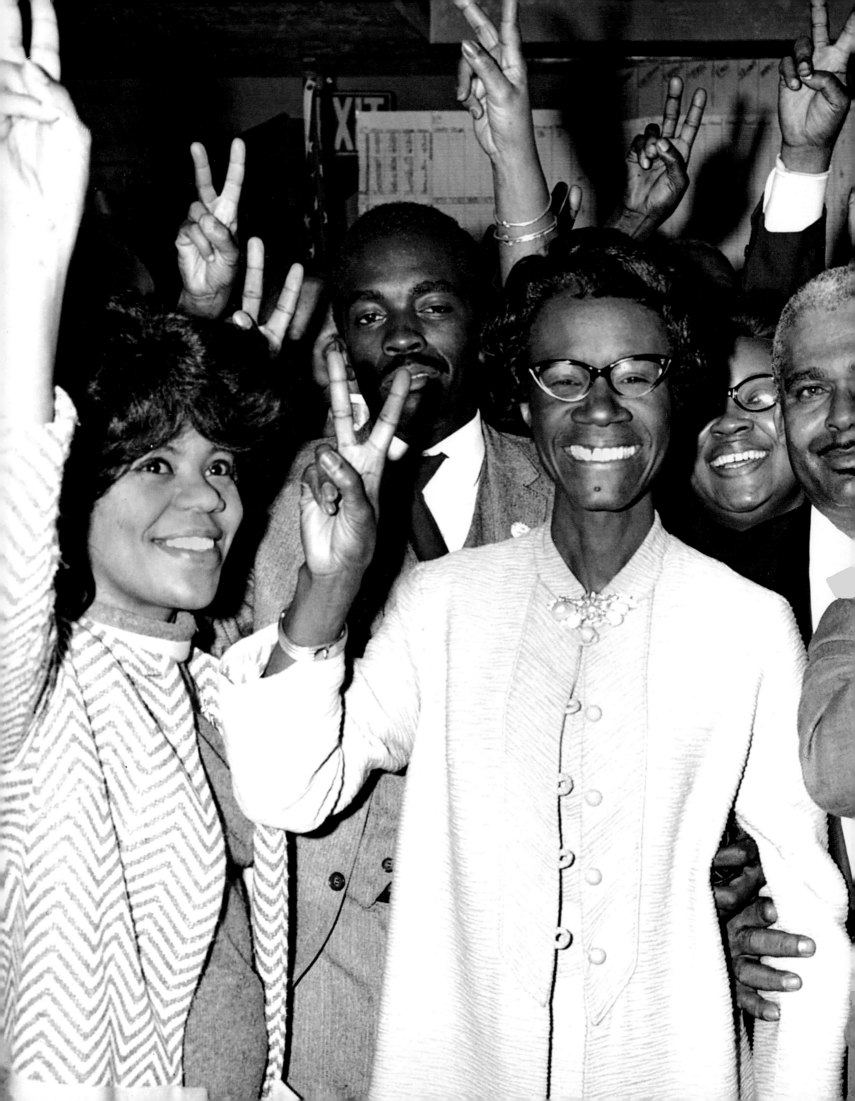

shirley chisholm (1924–2005)
didn't accept the status quo.

1946: graduates *magna cum laude* from brooklyn college, where she was a member of the harriet tubman society, which fought for integration of the troops during the end of world war II, for courses in african-american history and for women's participation in student government.

1946: is a nursery school teacher and daycare center director in brooklyn, NY.

1952: earns a graduate degree in early childhood education from columbia university. a strong debater, she's encouraged to get into politics by one of her professors.

1964: wins a landslide victory for a seat in the new york state assembly. sponsors the SEEK (search for education, elevation and knowledge) program, which allows disadvantaged students to attend college with intensive educational support. she also works for the legalization of abortion, access to child care, maternity rights for teachers and legislation for domestic workers' rights.

1968: her congressional campaign slogan: "fighting shirley chisholm—unbought and unbossed."

1968: is the first african-american woman elected to the united states congress. she defeats civil rights activist james farmer to represent brooklyn's 12th district. it's a position she holds for fourteen years.

1969: in her first few days at the capital, ignores the tradition that new lawmakers should be seen and not heard and protests her assignment to an obscure committee on forestry and rural villages, on the house floor. "apparently all they know here in washington about brooklyn is that a tree grew there," she said. "i can think of no other reason for assigning me to the house agriculture committee." she's moved to the veterans affairs committee and notes approvingly that there are a lot more veterans than trees in her district.

1969: speaking out aginst the vietnam war in her first floor speech on march 26th, vows to vote against any defense appropriation

bill "until the time comes when our values and priorities have been turned right-side up again."

1969: with bob dole (R), she creates the special supplemental nutrition program for women, infants and children (WIC), which gives low-income women, infants and children access to nutritious foods. she also sponsors increases in federal funding to extend daycare operating hours and guarantee a minimum annual income for families.

1969: elected honorary chair of NARAL (national abortion rights action league).

1969: introduces the equal rights amendment to the house of representatives. "the happy little homemaker and the contented 'old darkey' on the plantation were both produced by prejudice," she told congress in one of three major speeches she gave during deliberations before helping secure its ratification in 1972 (only for it to fall three states short of the thirty-eight required to put it in the constitution ten years later). "…what we need are laws to protect working people, to guarantee them fair pay, safe working conditions, protection against sickness and layoffs and provision for dignified, comfortable retirement. men and women need these things equally. that one sex needs protection more than the other is a male supremacist myth as ridiculous and unworthy of respect as the white supremacist myths that society is trying to cure itself of at this time."

1970: "that i am a national figure because i was the first person in 192 years to be at once a congressman, black and a woman proves, i think, that our society is not yet either just or free."

1970: her memoir: *unbought and unbossed.*

1970: "one bill that i introduced should become law in every state, but unfortunately

it did not succeed even in new york. it would have made it mandatory for policemen to successfully complete courses in civil rights, civil liberties, minority problems, and race relations before they are appointed to a police department."

1970:

"my role, i think, is more that of a catalyst. by verbalizing what is wrong, by trying to strip off the masks that make people comfortable in the midst of chaos, perhaps i can help get things moving."

1970: "no one has a right to call himself a leader unless he dares to lead. that means standing up to be counted on the side of his people, even at the risk of his political security."

1971: is one of 320 founding members of the national women's political caucus, along with bella abzug, betty friedan and gloria steinem.

1971-1977: serves on the committee on education, and later on the committee on organization study and review. sponsors a national student lunch bill and organizes her colleagues in order to override president gerald ford's veto to pass it.

1971: helps found the congressional black caucus in response to the increasing number of african-americans serving in congress and the desire for a formal organization to "fight for justice, to raise issues too long ignored and too little debated."

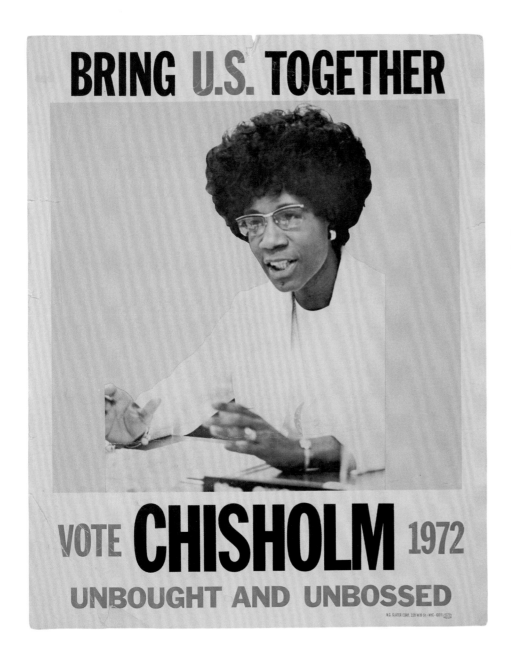

BRING U.S. TOGETHER

VOTE **CHISHOLM** 1972
UNBOUGHT AND UNBOSSED

N.G. SLATER CORP, 220 W19 St – NYC –0011

1972: she's defeated, but predicts that future political campaigns by women and minorities will have a smoother path "because i helped pave it." she sees the race as a platform to activate people who traditionally didn't participate in politics. in chisholm's office, all of her staffers were women; half of them african-american.

1974: the national gallup poll lists her as one of the top ten most–admired women in america—ahead of jacqueline kennedy onassis and coretta scott king and tied with indian prime minister indira gandhi for sixth place.

1976:

"my role is to break new ground in congress. i can talk with legislators from the south, the west, all over. they view me as a national figure and that makes me more acceptable."

1977: elected to the rules committee, which is in charge of permitting the consideration of a legislative measure and prescribing conditions for its debate and amendment. it's one of the most powerful committees in congress. she's the first black woman—and the second woman ever—to serve on that panel.

1977: founding member of the congresswomen's caucus.

1977–1981: serves as secretary of the democractic caucus.

1982: leaves congress. "we still have to engage in compromise, the highest of all arts. blacks can't do things on their own, nor can whites."

1971: boycotts president nixon's state of the union address in january for his refusal to meet with the congressional black caucus; nixon agrees to a meeting in march.

1972: is the first black woman to seek a major party nomination for president. in a race with twelve other candidates, her goal is to reach the democratic national convention with a strong show of support. during her campaign, she wins a federal court order to participate in a televised debate with the presidential front-runners under the equal time provisions of the FCC and talks directly to a national television audience. carries one hundred and fifty-one delegates (10%) at the DNC and wins the right to speak from the main podium.

"i had something important to explain," she later said about her historic speech. "i ran because somebody had to do it first. i ran because most people thought the country was not ready for a black candidate, not ready for a woman candidate. someday. it was time in 1972 to make that someday come."

she is generous with advice and frugal with criticism.

nina simone (1933–2003) played and sang jazz, blues and
folk music. she played and sang her truth. "mississippi goddam,"
"four women" and "to be young, gifted and black" were just a
few of the songs that nodded to her resolute civil rights activism.
(the first was in response to the 1963 assassination of medgar
evers and a birmingham church bombing that killed four african-
american girls. she wrote it in under an hour.) she learned piano at
age 3, trained at julliard in new york city and wanted to be the
first major african-american concert pianist. she switched to playing
american standards in atlantic city nightclubs in the 1950s before
recording forty-six albums and playing carnegie hall—but she
did splice a bach fugue through her 1958 song "love me or leave
me." she sang "brown baby"—filled with hope for racial
equality—outside a black college at the first integrated concert
in birmingham, armed guards and dogs roaming the field.
she performed "mississippi goddam" outside montgomery, alabama
on a makeshift stage atop empty coffins lent by local funeral
homes, the fourth and final night martin luther king, jr. and three
thousand nonviolent protestors marched the fifty-four-mile
route from selma to the state capital building. she entertained
them alongside joan baez, harry belafonte, tony bennett,
leonard bernstein and sammy davis jr. twenty five thousand
people came to listen. she was born eunice kathleen waymon. she
renamed herself nina (from the spanish word "niña," or
"the girl") simone (after french film star simone signoret).

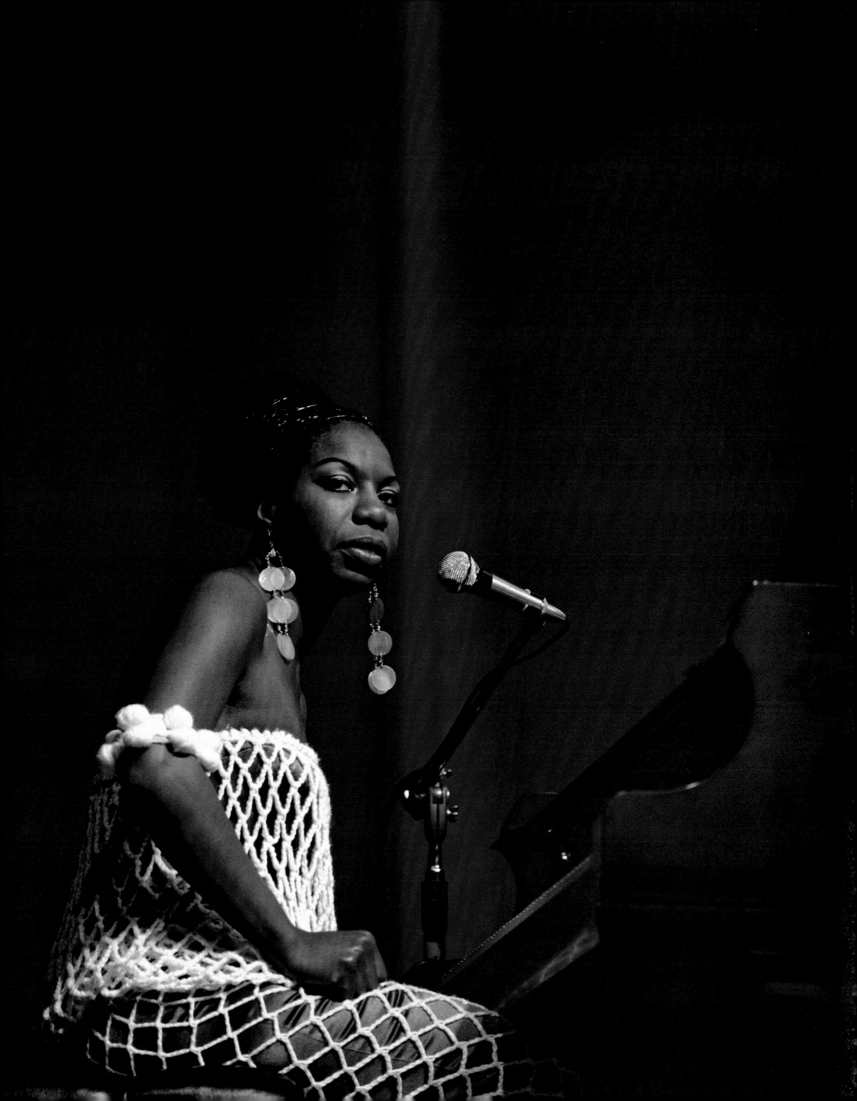

"an artist's duty, as far as i'm concerned,
is to reflect the times. i think that is true of painters,
sculptors, poets, musicians. as far as i'm concerned
it's their choice, but i choose to reflect the times and
situations in which i find myself. that to me is
my duty. and at this crucial time in our lives, when
everything is so desperate, when every day is a matter of
survival, i don't think you can help but be involved.
young people, black and white, know this. that's why they're
so involved in politics. we will shape and mold
this country or it will not be shaped and molded at
all anymore. so i don't think you have a
choice. how can you be an artist and not
reflect the times? that to me is the
definiti•n of an „
artist."

—nina simone

she cultivates optimism.

"you get people who have their own
ideas of what your pictures
should be like. my pictures are going
to be on my terms."

eve arnold (1912–2012) studied medicine before taking up
photography (and only by chance: someone gifted her a camera).
bar a short course she took with *harper's bazaar* art director
alexey brodovitch at the new school for social research, she taught
herself. she was the first woman hired by magnum photos agency
in 1951 in the golden (and very macho) age of photojournalism.
her photos and essays mixed distanced reportage and familiar
intimacy. she fostered long-term relationships with her subjects
and treated celebrities (joan crawford, marlene dietrich, queen
elizabeth II) with the same care and sensitivity as she did unknown
subjects: to her, they were the same. she always only used natural
light. she covered the 1952 republican national convention
in chicago (the era of "i like ike") and the mccarthy hearings.
she followed activist malcolm x for almost a year from washington
DC to new york to chicago for a 1961 photo-essay in *esquire*. she
documented mongolian horse trainers and cuban prostitutes,
soviet political prisoners and migrant potato pickers in small-town
america. she followed the outcomes of newspaper personal ads in
london for *queen* magazine. her film *behind the veil* (1972) recorded
the role of women in muslim society. her book *the unretouched
woman* (1976) expressed the lives of women worldwide. she
was one of nine children of russian immigrants in philadelphia.
she was marilyn monroe's favorite photographer.

6.

she's
a
work of art
and
likes to look
at it, too.

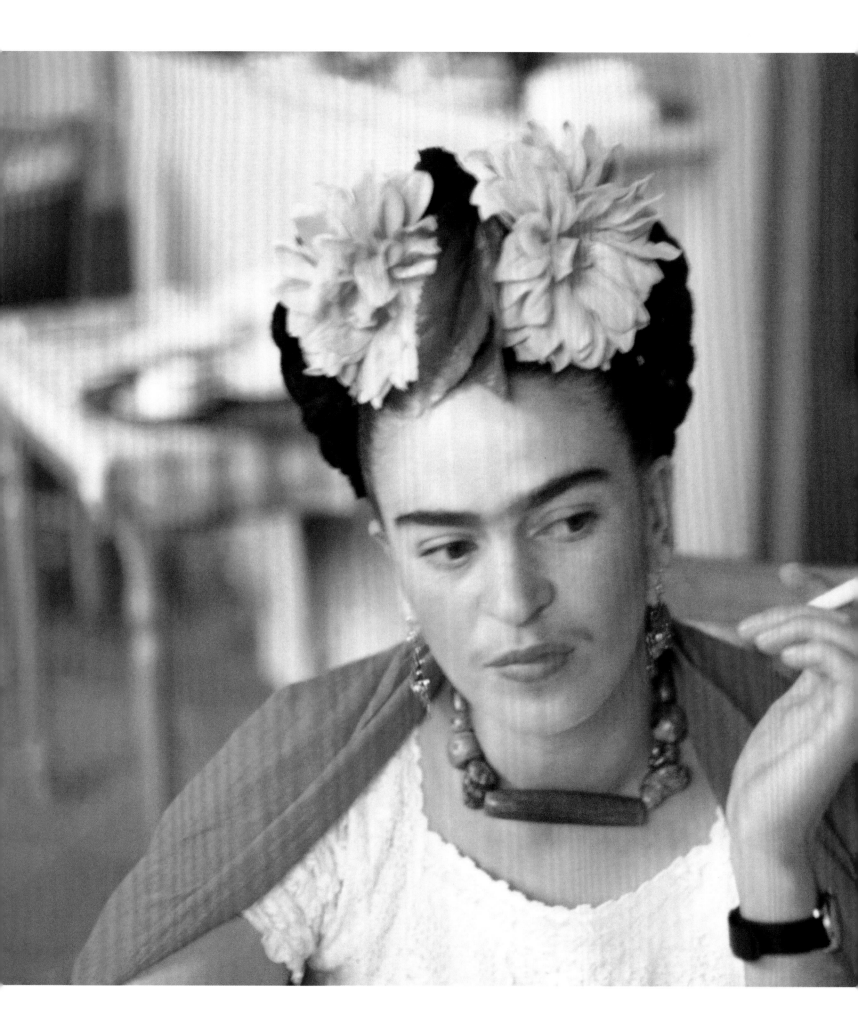

frida kahlo (1907–1954) lived in mexico city and painted frank and beautiful images of the natural world— her home, her garden, herself. they reflected love, loss, national identity and ideas that challenged beauty norms when audacious self-disclosures (miscarriage; infidelity; breastfeeding; illness; a monobrow) were taboo. her art was an autobiography. she began in 1926, bedridden after a streetcar accident broke her spine and pelvis. she showed and lived in mexico city, new york, san francisco and paris. she painted herself because she was the subject she knew best, and the world found strength in what she saw.

she wears her heart on her sleeve.

"above all else, be true.
be true to yourself, your values,
your convictions."

chimamanda ngozi adichie (1977–) tells stories within
stories, overlapping perspectives of richly complex characters;
realist fiction (*purple hibiscus, half of a yellow sun*) set on a continent
that is often otherwise seen by much of the world as possessing a
single story: africa. she writes about america (*americanah, the thing
around your neck*), her part-time homeland, too. "now is the time
to talk about what we are actually talking about" she titled her
new yorker essay in the wake of the 2016 elections, a rallying cry for
a diverse freedom of voices in a country born of the liberty of
self. she is nigerian. black. feminist. igbo. a writer. a recipient of
the macarthur genius grant. a graduate of yale. she did fellowships
at princeton and harvard. but it's amiss to categorize her as any
one or two or three of these things because it's the sum of *all* of
her parts that creates her story. "culture does not make people,"
she wrote in her 2014 speech-turned-book *we should all be feminists*.
"people make culture. if it is true that the full humanity of women
is not our culture, then we can and must make it our culture."

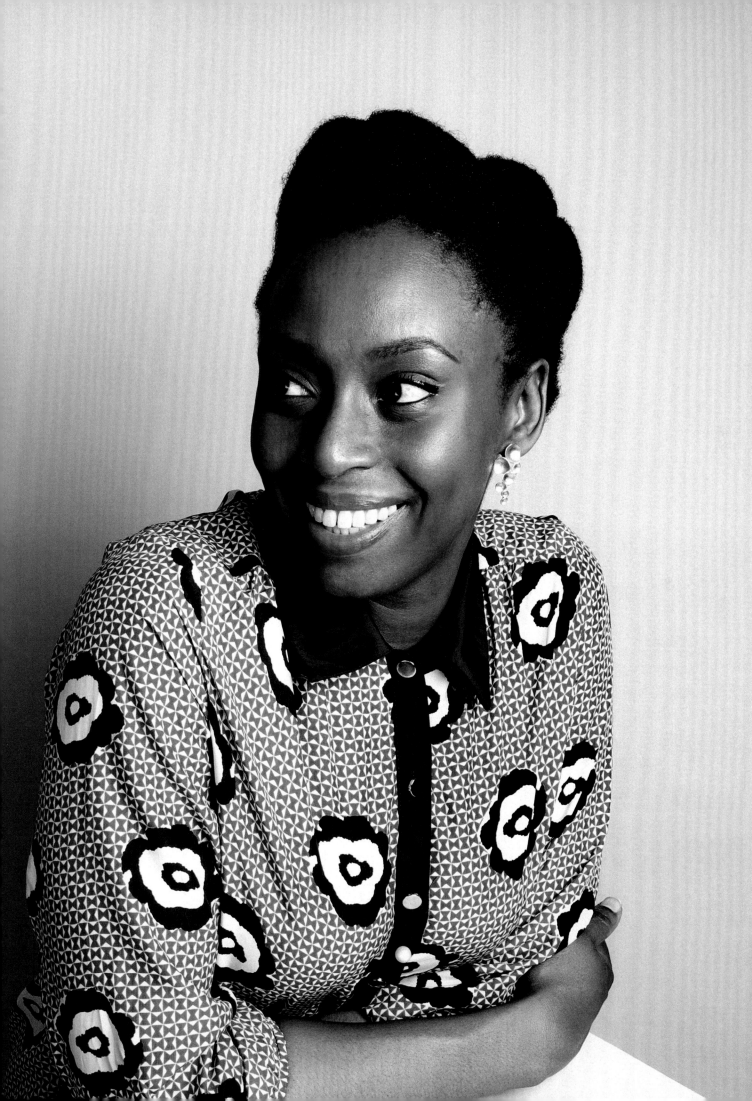

"you can see what's out there
and try to emulate it,
or you can try to find something that
is yours and run with it."

emma summerton (1970–) has a fine artist's eye and a
fashion photographer's lens. she takes bold, colorful, strong
images of women for clients like *vogue* (italian, british, american,
german, australian), *W*, *i-D* and *self service*—and sometimes of
herself. she studied fine arts in sydney and splits her time between
new york city and london, inspiring her subjects and viewers to be
their greatest imagination of themselves. "one of the things i try to
show is that it's good to be a sexy woman for yourself and for your
fellow women, rather than only to entice a man's gaze. so hopefully
there is something in my work that women see and relate to, because
fashion—what i shoot—is about women. i don't want to alienate
other women, i want to invite them to get into it, and feel inspired
and creative in the way that they dress, or the way that they do their
hair and makeup, and the way that they are in the world. fashion
has the ability to transcend the everyday experience of our lives,
so it's more of wanting to share, rather than exclude."

EMMA'S
FOCUSED.
IT ALL JUST CLICKED.

what do you do best? imagine and create.

earliest memory related to who you are today? laying on my horse's
back at night in the suburbs of australia, dreaming about freedom and other places but
having no idea how to get there—but holding a feeling that if i imagined
anything was possible, it probably was.

why are you a photographer? it's the path of creativity that opened to me.
i just wanted a free and creative life.

what would you do if you weren't a photographer? if i was something
else it would probably be a painter.

what's a big risk you're glad to have taken? leaving australia for london just when
i had stopped assisting and was starting to shoot for australian *vogue*.
i had no job lined up, barely any money and somewhere to live for only a month but
i thought what the hell...let's see what happens.

your proudest moment so far? my first shoot for italian *vogue*. i had seen
the magazine when i was in australia and part of the reason i left for europe was to work for them—
i saw it as a perfect mix of fashion and art. when franca sozzani,
its editor-in-chief, said "yes" to me via edward enninful's introduction, it seemed surreal.

**if you could lose yourself for a day, where would you go and what
would you be looking at?** i would transport myself back in time to when vali myers
was alive and watch her paint in positano.

you photograph a lot of women. do they inspire you? women totally inspire me, every day—
from my family to my friends to my work colleagues to women i see walking
down the street. i love hearing their stories, imagining their stories, seeing their style and
learning from them—taking things to grow me.

if you could relive a day of your life, which would it be? no redos...
just forward, thank you.

what brings you joy? people i love and share my life with—cooking for them,
nurturing them, learning with them. time and how it enriches our lives. knowing someone for
a long time. it's wonderful, fulfilling and comforting.

she's one of a kind.

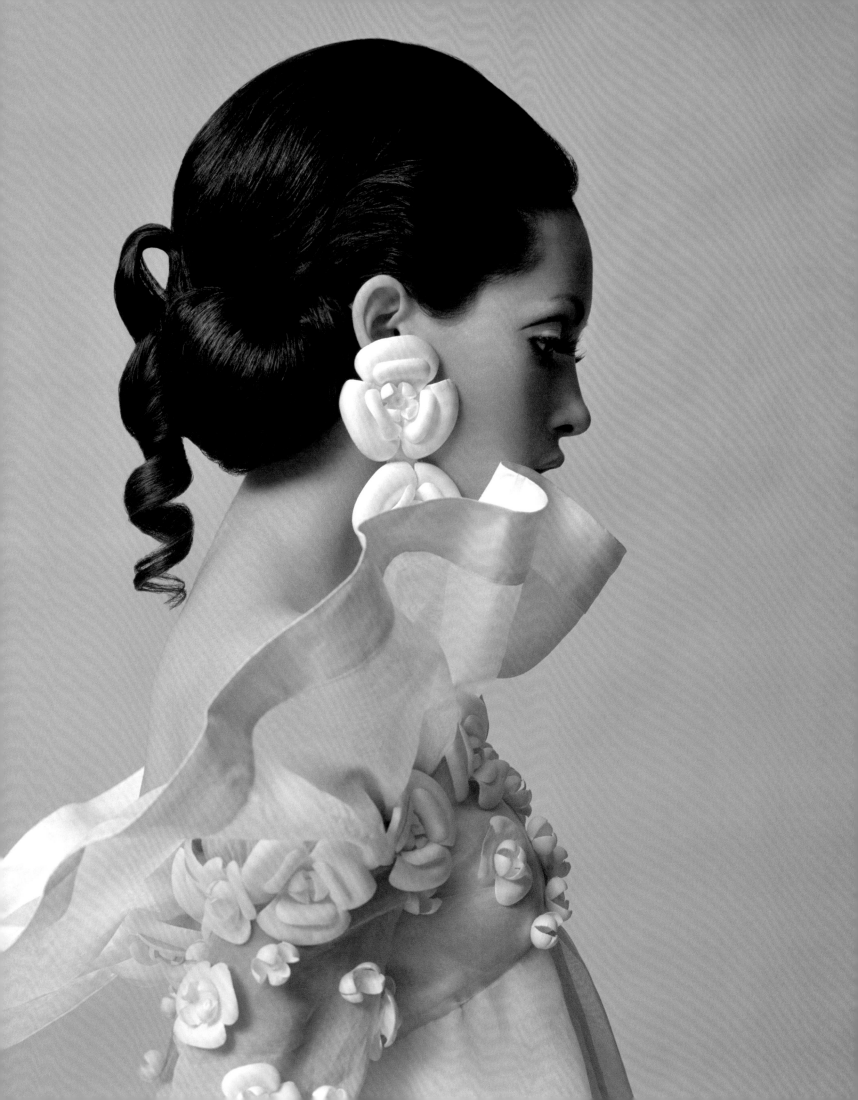

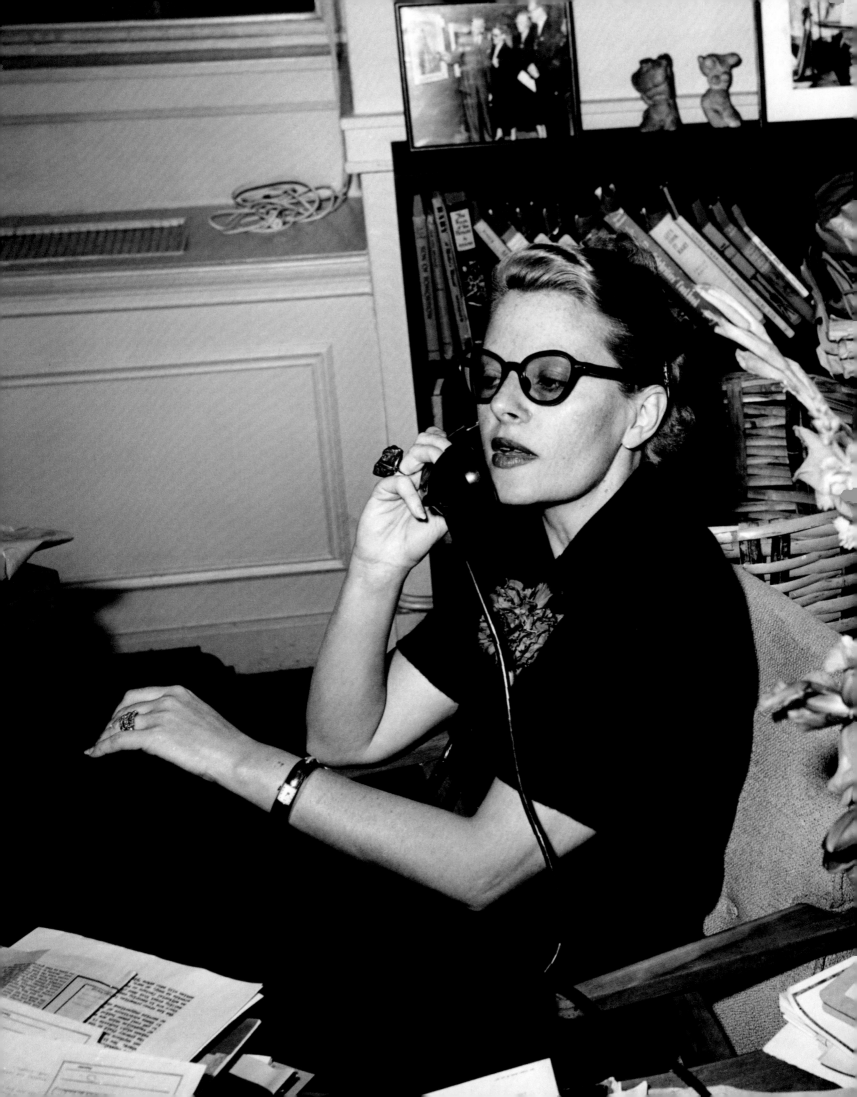

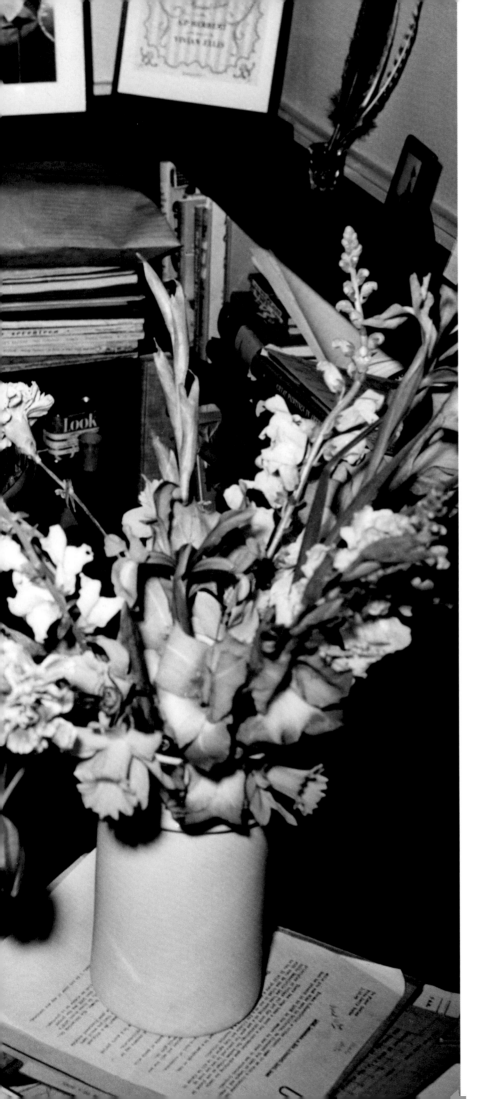

fleur cowles (1908–2009) launched *flair* in 1950,
the most lavish magazine to ever grace the newsstands.
it featured cut-out covers, different paper stocks,
pop-ups, removable reproductions of artwork, stories
by tennessee williams and simone de beauvoir and
illustrations by picasso, gruau and freud. even winston
churchill. each issue was like a public portfolio of fleur's
brave taste—covering fashion, décor, art, travel, literature
and her other interests—and in its twelve short-lived
issues became her "lifetime passport." but before all that,
the new yorker wrote speeches for the war production
board in washington DC and concepted a media
campaign for president truman's feminine emergency
committee to reduce cereal consumption in america
so that surplus grain could be sent to europe after
world war II. she redesigned *look* magazine in 1947 and
invented the formula that later became the newspaper
color magazine insert. she was a painter who loved roses.
she changed her name from florence to fleur. she had
the queen mother over for dinner. she was a senior fellow
of the royal college of art in london and a trustee of the
jersey wildlife preservation. she helped build the institute
for american studies at oxford university. "i have an idea
a minute," she once said. "i'm a born idea myself."

151

THE "FLOWER GAME" – INVITATIONS SENT TO PARTICIPATE

Name	Date sent	Reply Date	Name	Date Sent	Reply Date	
1	Mrs. Dart	30/1/79		Madam Pandit	33 5/1	July 28
2	Mrs. J. Stewart (& mr)	30/1	28/2 (36)	Princess of Berar	34 22/1/79	
3	Mrs. H. Wilson	30/1	22/2 (26)	Ingrid Bergman	35 How	
4	Baron Boel, Belgium	30/1	21/2 (24)	Betsy Drake	36 31/1	19/2 (18)
5	Margot Fonteyn	30/1	16/3 (62)	Cary Grant	37 31/1	23/2 (28)
6	Lady Thorneycroft	30/1	22/2 (16)	Harold Prince	38 31/1	16/2 (10)
7	Baron Philippe de Rothschild	30/1	(104) 6/6	Dr. F. Kerdel Vegas	39 31/1	13/3 (55)
8	Michael York	30/1	26/2 (30)	Marc Cathey	40 31/1	24/4 (90)
9	Lauren Bacall	30/1		Madam Plesch	41 31/1	8/5 (91)
10	Christina Foyle	30/1	7/2/79 (3)	Margaret Jay	42 31/1	21/2 (23)
11	Gerald Durrell	30/1	12/2/79 (4)	Mr. Etienne Dreyfus	43 31/1	
12	Lady Bird Johnson	30/1	20/2 (19)	Stanley Marcus	44 31/1	21/2 (22)
13	Beverley Nichols	30/1	5/2/79 (2)	Richard Horchow	45 31/1	19/2 (12)
14	Princess Grace	31/1	13/3 (64)	Mrs. Sarah Massey	46 31/1	
15	Madam Sadie, Brazil	31/1	20/3 (66)	Mrs. Marshall Steves	47 31/1	15/3 (60)
16	Lucky Roosevelt	31/1	26/3 (72)	Mr. Russell Page	48 2/2	
17	Evangeline Bruce	31/1	5/3/79 (39)	Sir Cecil Beaton	49 7/2	19/2 (13)
18	Trudy Sundberg	31/1	15/3/79, 69	Sr. Salvador Dali	50 8/2	
19	Mrs. Coetzee	31/1	7/3 (48)	Mrs. A. Roosevelt (repeat)	9/2	(72)
20	Trader Vic	6/2	27/2 (35)	Jean Muir	51 13/2	20/3 (67)
21	Mary Sinclair	31/1	6/3 (46)	Dr. Henry Moore	52 13/2	2/2 cannot
22	John van Eyssen	31/1	16/2/79 (9)	Norman Parkinson	53 13/2	22/5 (104)
23	Paul Dufau	6/2	15/2/79 (7)	Anne Scott-James	54 13/2	22/2 (27)
24	Morgan Wheelock III	31/1	19/2 (14)	Lady Collins	55 13/2	19/2 (14)
25	Tamayo (Mexico)	31/1	24/4 (91)	Roy Strong	56 13/2	26/3 (71)
26	Amb. da Costa	31/1	9/3 (52)	Rupert Lady Nevill	57 13/2	4/6 (108)
27	Baroness Bentinck	31/1 (Gillott)	14/2/79 (6)	Janet Suzman	58 13/2	27/2 (34)
28	Queen Mother Eleanor Lambot	31/1	cannot	Lord Wolfenden	59 13/2	26/2 (31)
29	Elaine Dreyfus Dupt.	31/1	(11) 19/2/79	Norman St John-Stevas	60 13/2	Aug 11 (116)
30	Mary Spain	31/1	5/2/79 (1)	Lady Widgery	61 13/2	21/2 (21)
31	Mme. Aso (Japan)	31/1	5/3/79 (38)	Jane Goodall	62 13/2	8/3 (51)
32	Madam Tomita	31/1	13/2/79 (5)	Mrs. Robert Herring	63 13/2	26/2 (33)
		30			25	

a list of contributors to her book, the flower game, *mid-progress.*

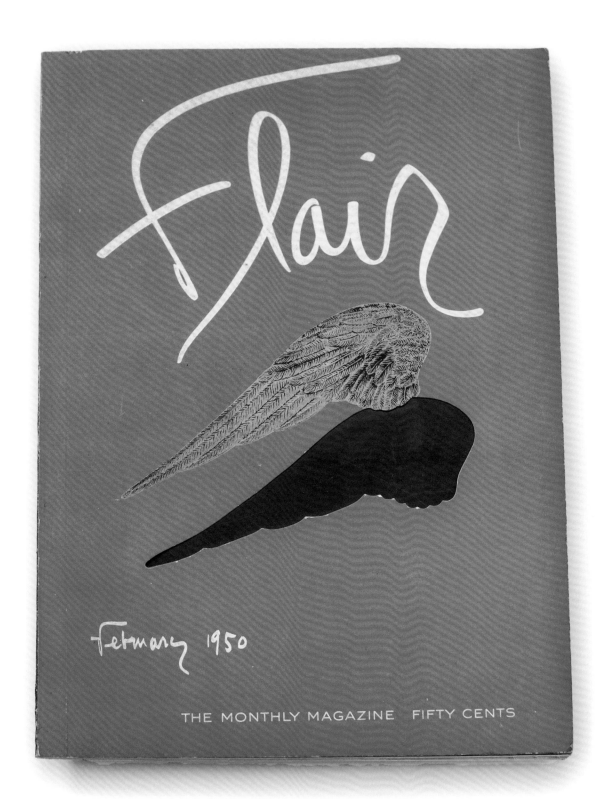

her very first issue.

peggy guggenheim (1898–1979) called herself the "midwife" of art. she was a guggenheim (of the guggenheims) who didn't professionally enter the art world until she was 39. she championed outsiders who became the greatest abstractionists, expressionists and surrealists of the 20th century—she gave jean cocteau his first show and early boosts to jackson pollock, wassily kandinsky, robert motherwell, yves tanguy and more at her galleries in new york and london. she lived in paris from the 1920s until the middle of world war II and collected art until the very last minute. at the war's height she bought one piece a day—including ten picassos, forty ernsts, eight mirós, four magrittes, three man rays and three dalís—and escaped to new york city with hundreds of pieces in tow two days before the germans invaded. she put on one of the first-ever art shows devoted exclusively to female artists—frida kahlo, included. she had fourteen dogs. she purchased the palazzo venier dei leoni on the grand canal in venice (owned at one time by fellow madcap heroine marchesa luisa casati) in 1949 and filled it with all those pieces by man ray, rothko, kandinsky, mondrian, magritte and braque. alexander calder sculpted the silver bedstead that supported her mattress. she made it her home and art hall for thirty years and in 1951, opened it to the public. it's the second most visited museum in venice today. in her own way, she defined the story arc of modern art.

7.

she's
one smart
cookie.

leandra medine (1988–) has designed eccentrically sensible shoes, coined outlandishly practical phrases ("arm party": a stack of bracelets) and considers pants optional. she started a freethinking fashion blog in 2010 about trends women love that men hate—turbans, overalls, shoulder pads, fringe, etc. etc. etc.—that mixed high fashion and comedy. then she applied that formula to unapologetic think-essays on other everyday things women should feel comfortable in their own skin about—like their spending, shopping and sugar addictions, how to do small talk if you hate small talk—creating, along the way, a media brand that's authentic and candid. see: her book of personal essays, *man repeller: seeking love, finding overalls.* hear: her two podcasts "oh boy" and "monocycle." she's a daily reminder to do what you love and you'll never go wrong. (but if you do, so what?)

159

20
THINGS THAT ATTRACT
LEANDRA.
(AND TWO THINGS THAT DON'T.)

uptown or downtown? my answer is a timeline.
1988–2005 it was uptown. 2005–2016 it was downtown. 2017–who
knows, it's back uptown.

if you could share a taxi with anyone, who would it be?
david foster wallace, but we'd have to be going to florida or somewhere
really far so that we had ample time to talk.

what virtue is completely overrated? empathy. compassion
is much more important.

what quality do you most like in a man? sincerity.

what quality do you most like in a woman? self-awareness.

favorite indulgence? a ninety-minute massage.

**what's a piece of advice you've given someone that you haven't
followed yourself?** we are who we are, but given the characteristics
that define us—whether good or bad—we have the choice
to channel them however we please.

lips sealed or open book? open book.

memorable entrance or memorable exit? memorable entrance.

what little thing do you appreciate the most? kindness for no reason.

what's your morning beverage? coffee with a tablespoon of
ashwagandha mixed in.

e-mail or handwritten note? e-mail.

what word or phrase do you overuse? i say "multifarious" a lot—too much. "many" works just as well.

what word or phrase do you wish you used more often? "i'm really proud of myself."

what's your superpower? the ability to recognize immediately when i am being an asshole.

most surreal life moment? i feel like the past five years have been a surreal life moment.

if you could invite anyone to your dinner party, who would you invite first? my mom and then i would invite the queen because i know how obsessed mom is with her. (i've been to so many great dinner parties, why not throw one for my mother!)

favorite fictional heroine? MISS PIGGY.

what's your most treasured possession? not to sound corny, but YOLO– my husband's love for me.

who is your real-life hero? lately, it's me.

what's your motto? "this is water." i stole it from the aforementioned david foster wallace.

hedy lamarr (1913–2000) was the stone cold fox of hollywood's golden age, an actress who conquered the box office (see: cecil b. demille's *samson and delilah*, the highest grossing movie of 1949) and a genuine smarty pants. (though technically she preferred satin gowns.) in 1942, she invented spread spectrum technology, a coding system which made communication undetectable, to help allies defeat axis powers during world war II. her invention formed the technical backbone of wireless technology that makes even our common communication today—bluetooth mobile phones, GPS, wi-fi—possible. it was a little something she did in her free time.

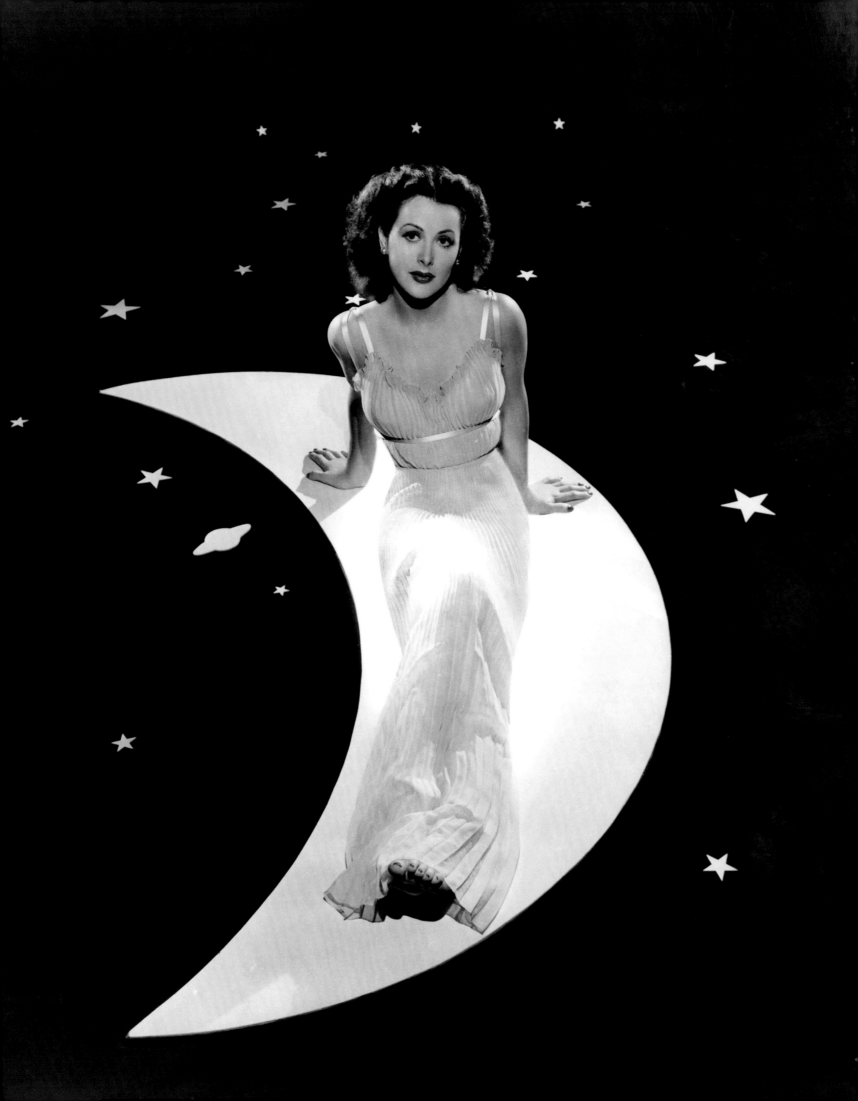

marilyn monroe (1926–1962) was a yogi long before it became popular, baptized by aimée semple mcpherson, painted by willem de kooning, analyzed by anna freud, married to arthur miller, studied method acting under lee strasberg and michael chekhov, was friends with poet edith sitwell, photographed by cecil beaton and bert stern and directed by laurence olivier, billy wilder and john huston. she was a hollywood illuminati who found a kindred spirit with the literati.

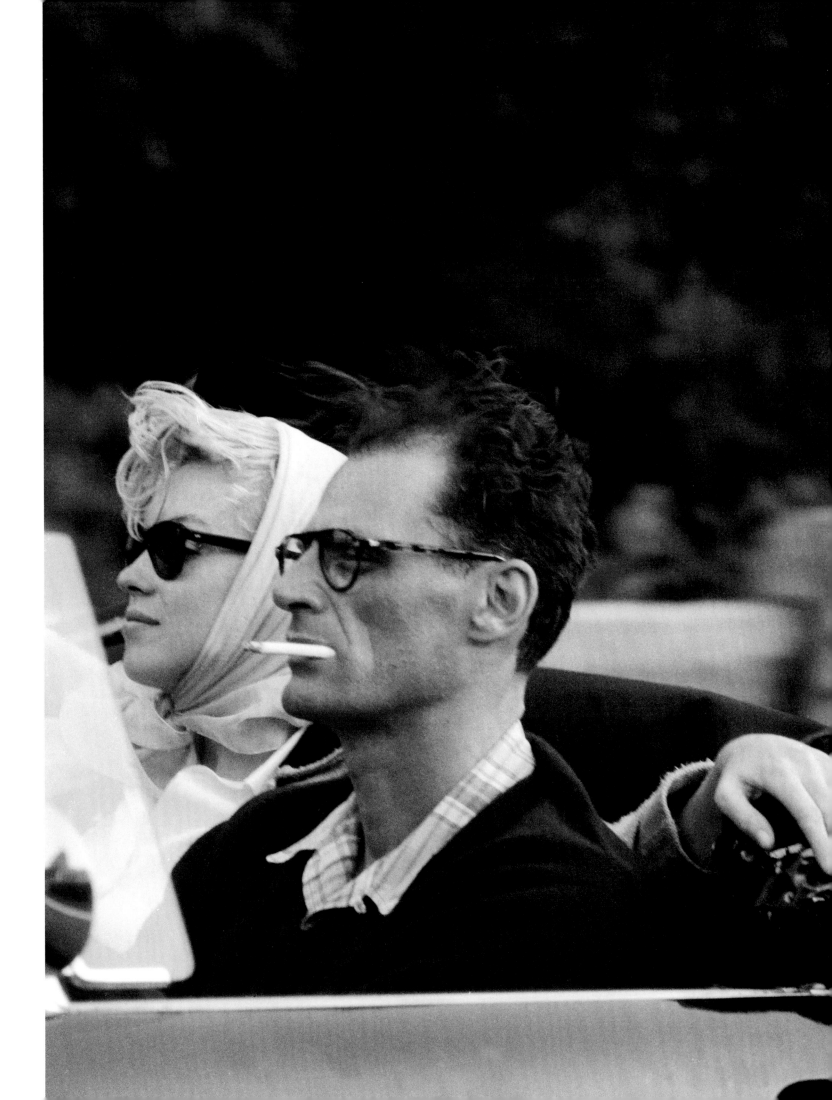

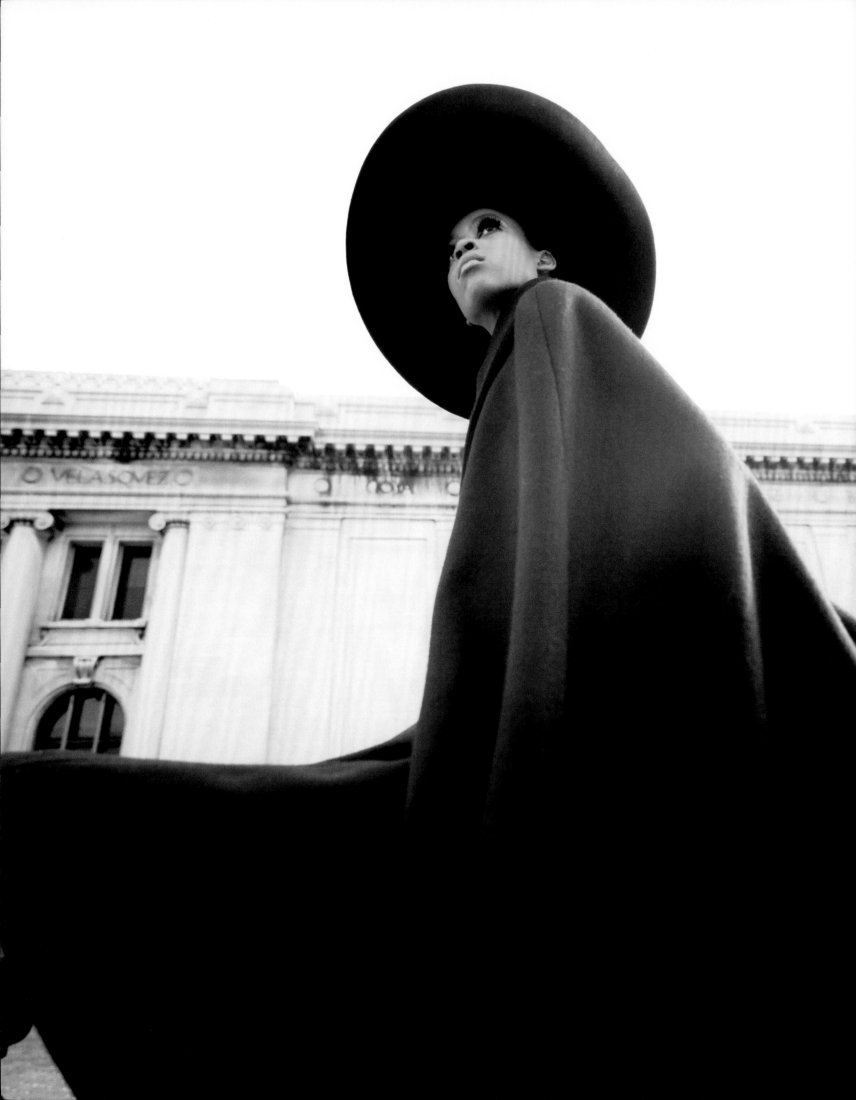

she's got a point of view that's never dull.

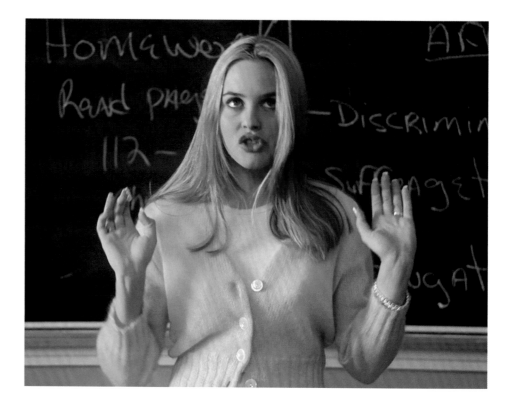

"so, okay. like, right now for example, the haiti-ans need to come to america. but some people are all, 'what about the strain on our resources?'"

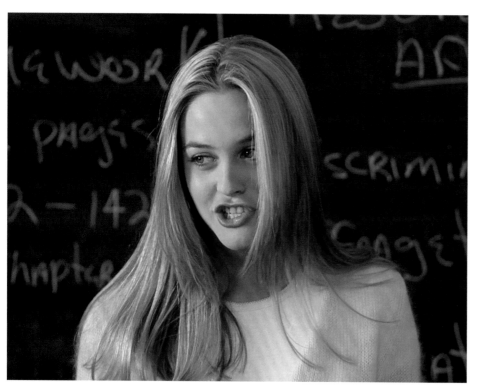

"well it's like when i had this garden party for my father's birthday, right? i said r.s.v.p. because it was a sit-down dinner. but people came that, like, did not r.s.v.p."

cher horowitz (*clueless*, 1995) orchestrated relationships for her own advantage and made over the school's new girl as a "pet project." she was a self-absorbed, self-righteous, *clueless* rich girl—a jane austen emma set in a '90s beverly hills high school. but never judge a book by its cover. after a series of interpersonal disasters—friendships broken, love potentially lost— she re-emerged with the same high-spirits, same nosiness, but channeled with sincerity.

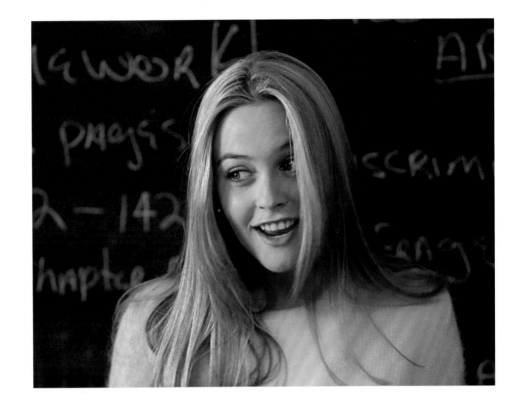

"so i was, like, totally buggin'.
i had to haul ass to the kitchen,
redistribute the food, squish
in extra place settings—but by
the end of the day it was, like,
the more the merrier."

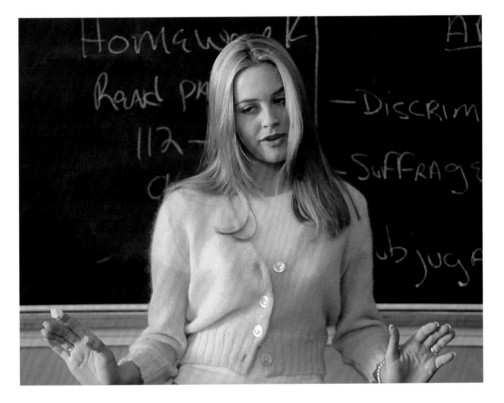

"and so, if the government
could just get to the kitchen,
rearrange some things, we could
certainly party with the haiti-ans.
and in conclusion, may i please
remind you that it does not
say r.s.v.p. on the statue of liberty.
thank you very much."

she gets lost at least once every day.

"love yourself
first and everything
else falls into line.
you really have
to love yourself to
get anything done
in this world."

lucille ball (1911–1989) made the outrageous believable.
on screen, she starred in the most successful comedy series
on television, *i love lucy*. off screen, she ran a major, innovative
hollywood production studio that also produced *star trek,
mission: impossible* and *the untouchables* for television and turned
los angeles into the television capital of the world. she and her
husband desi started desilu productions with $5,000. she sold it
for $17 million. she used humor to push social limits—her show
was the first to feature an interracial marriage, pregnancy—
and to upend gender roles. she courageously played a woman the
polar opposite of "ladylike," who complained and got dirty,
was clumsy, zany, opinionated, assertive and downright defiant
at times; america loved it. and they loved her for it, too.

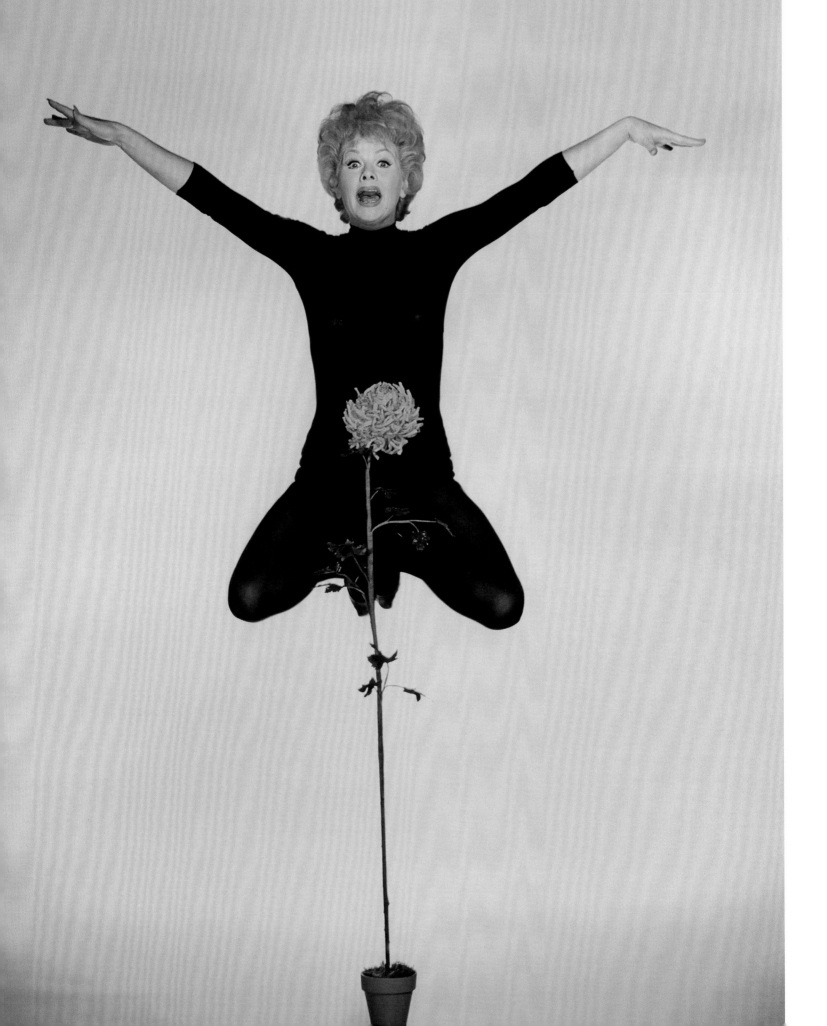

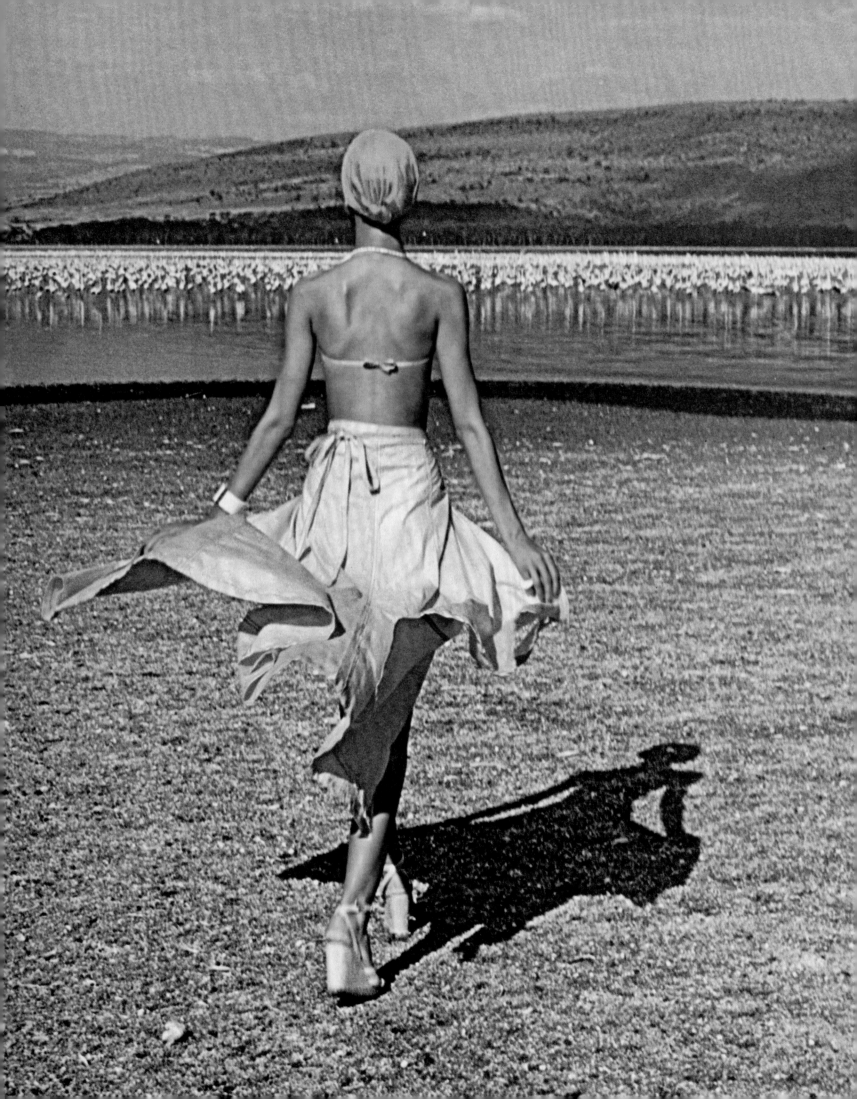

8.

she
married
adventure.

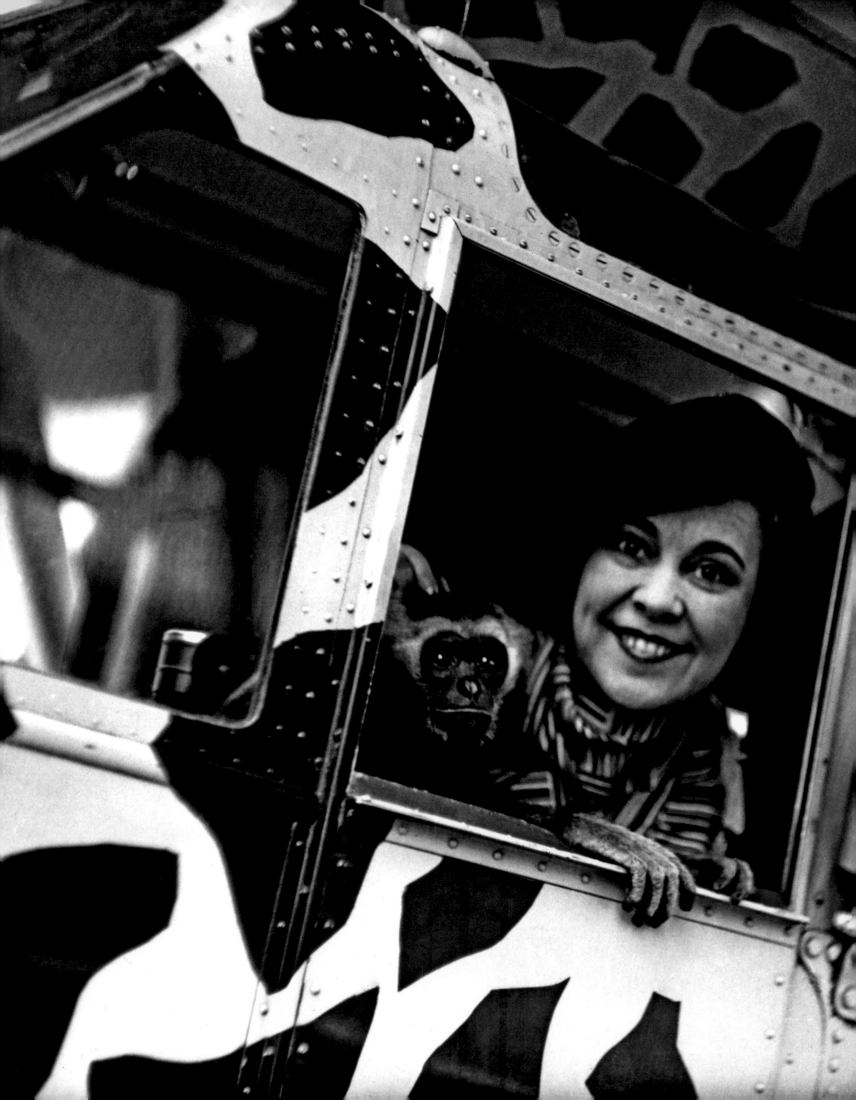

osa johnson (1894–1953) eloped from kansas at 16 with filmmaker martin johnson and began a lifelong travelogue tour of the planet's most uncharted territories. between 1917 and 1937 they set up camp in kenya, the congo, borneo and the south pacific. she hunted, fished and planted gardens; she procured supplies, piloted planes, hired guides and quickly learned local languages to act as a liaison between the crew and local subjects. she photographed elephants, giraffes, buffalo and more, figuring it out as she went along. she made films about native wildlife and centuries-old tribal customs that premiered across the globe and at new york's plaza hotel—including the first movie shot with sound in africa—gave lectures and penned magazine articles and children's books. she also literally wrote the book on marrying adventure. (her autobiography: *i married adventure.*) she hosted the very first wildlife series on television, took the first flight over mt. kinabalu (the tallest peak in southeast asia) and was named one of america's best dressed in 1939, along with bette davis. they called her "the heroine of 1,000 thrills." she said: "i am queen of the jungle."

linda benson (1944–) is the godmother of surfing.
she was the youngest person to enter the international surfing
championships at mahaka in 1959 (and won) and later that
year paddled out into hawaii's infamous waimea bay in the
middle of blinding offshore winds to catch its fifteen-foot waves.
her gutsy, flamboyant "hotdogging"—walking the board's nose,
pirouetting and hanging five—landed her on the cover of *surf
guide* in 1963. she played annette funicello's surfing double in
the beach party films (see: *muscle beach party, beach blanket bingo*)
and deborah walley's surfing double in *gidget goes hawaiian.*
in her first fifteen of thirty-eight years as a flight attendant she
worked the honolulu leg and surfed waikiki in the afternoon
until dark and then prepped for her return flight. she won over
twenty first-place surfing titles from 1959 to 1969, opened an
all-female "surfher" school and invented a surfboard carrier
called the rail grabber that she sculpted out of metal and plastic
herself. (she still assembles and packs them, too.) at 72,
she's surfing. "you've got your imagination. your knowledge.
your judgment. your board. and the wave," she explains.
"you can't plan it. it's just a beautiful, spontaneous thing."

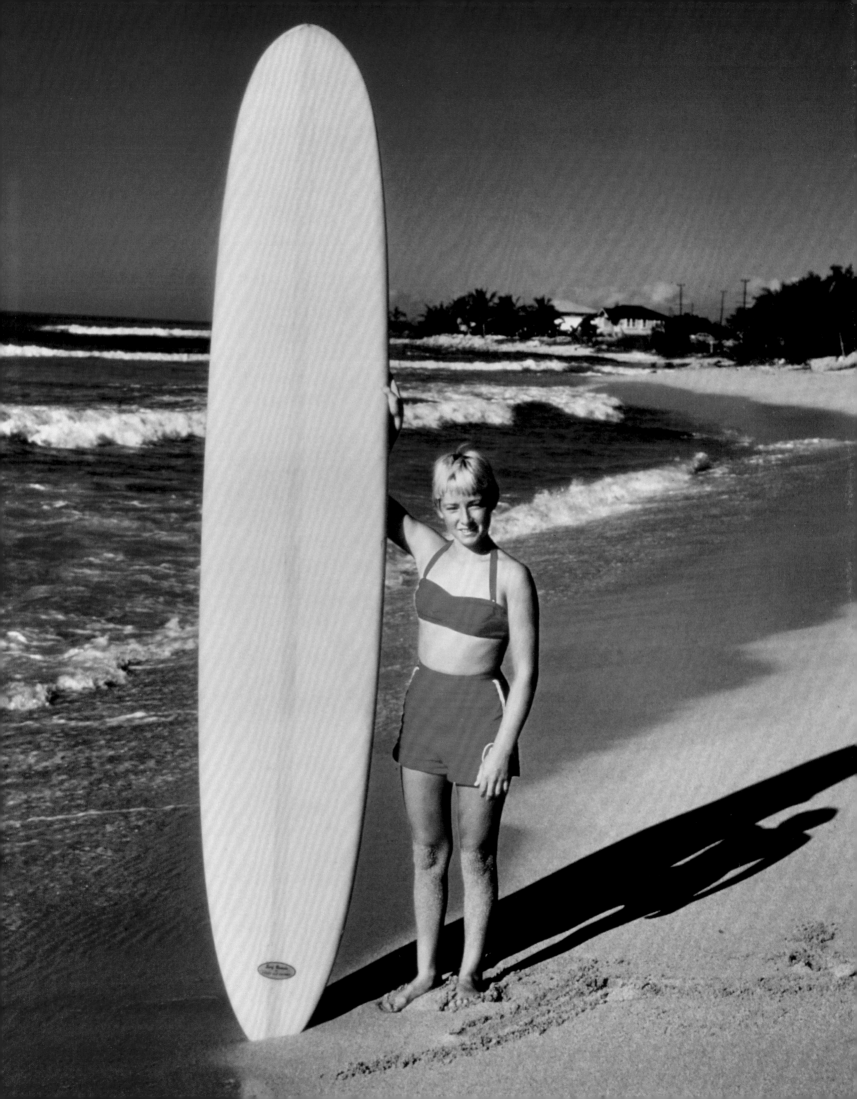

AS IN THE WAVES, AS IN LIFE.

LINDA

BREAKS DOWN

THE GOLDEN RULES OF SURFING.

understand your strengths.

apply them to new surfing spots. but don't go so far that you're a
potential hazard to yourself and those around you.

watch and learn.

the paddling surfer yields to the up and wave-riding surfer.
"when you're traveling, remember that you're in someone else's 'home break.'
so watch and learn. the locals can probably teach you something."

first come, first surfed.

after paddling out, find a spot within the "lineup"—the velvet rope of
the ocean. three rules of thumb: the surfer farthest out, waiting the
longest, or closest to the peak of the break wave has priority. "note: even if you
can paddle out the farthest and catch all the waves, it does
not mean you should. be fair."

be decisive.

whether paddling out of the way or tackling a wave, don't hesitate.
be deliberate with your movements.

keep your act together.

if you "kick out" or fall, control your "stick." loose or "thrown" surfboards
can injure or kill someone with their dense weight and sharp fins.

respect your surroundings.

never leave junk in a place that gives so much joy. only leave footprints in your wake.

admit when you're wrong.

if you inadvertently break one of these rules, check on the safety of
the slighted surfer and offer a sincere apology. "i got an apology once via facebook
days after returning from a surf trip," she remembers. "he'd cut me off
but ended up becoming the sweetest, dearest friend. matter of fact, i now
stay in his beach house sometimes."

surf in excess.

the sport has a steep learning curve. so get off the sandy
sidelines and into the water.

be encouraging to others.

"if someone hasn't had a wave all day, you tell 'em to go for it,"
linda says. "or if you spot a beginner, yell, hoot and applaud. or simply give
a thumbs up. they'll just beam."

she loves long walks and flights of fancy.

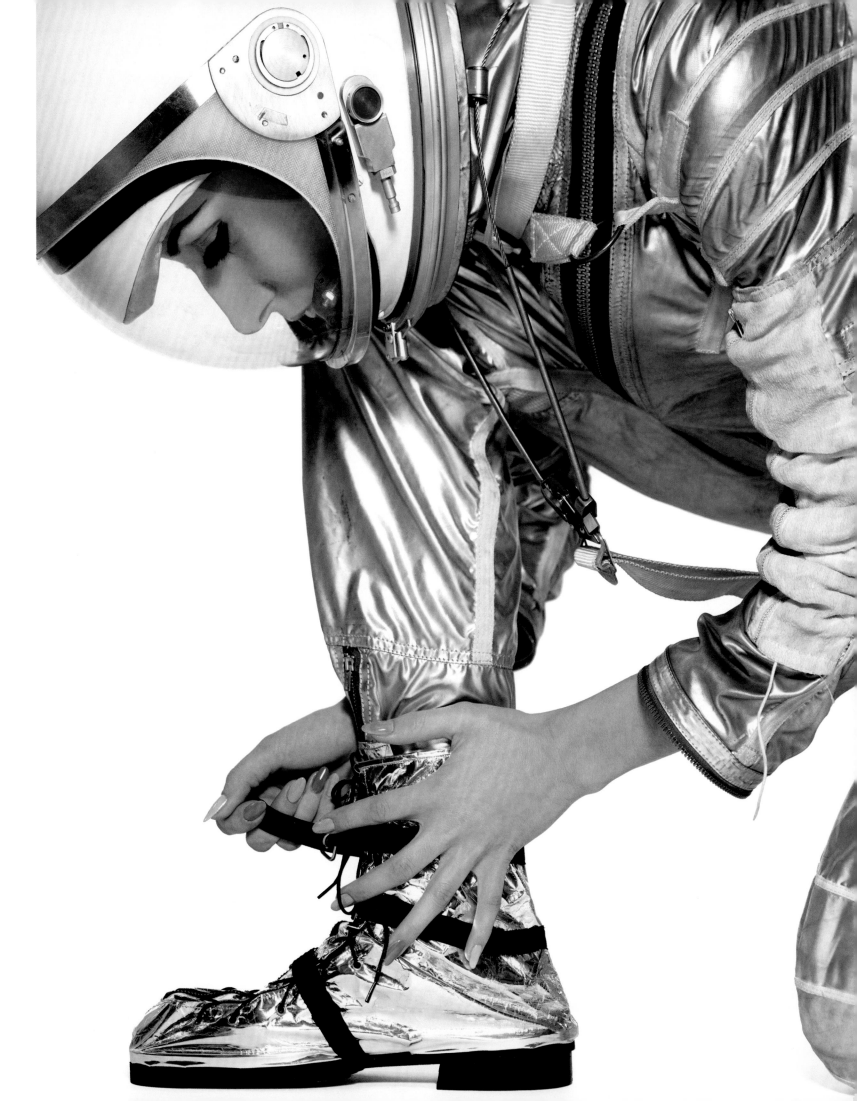

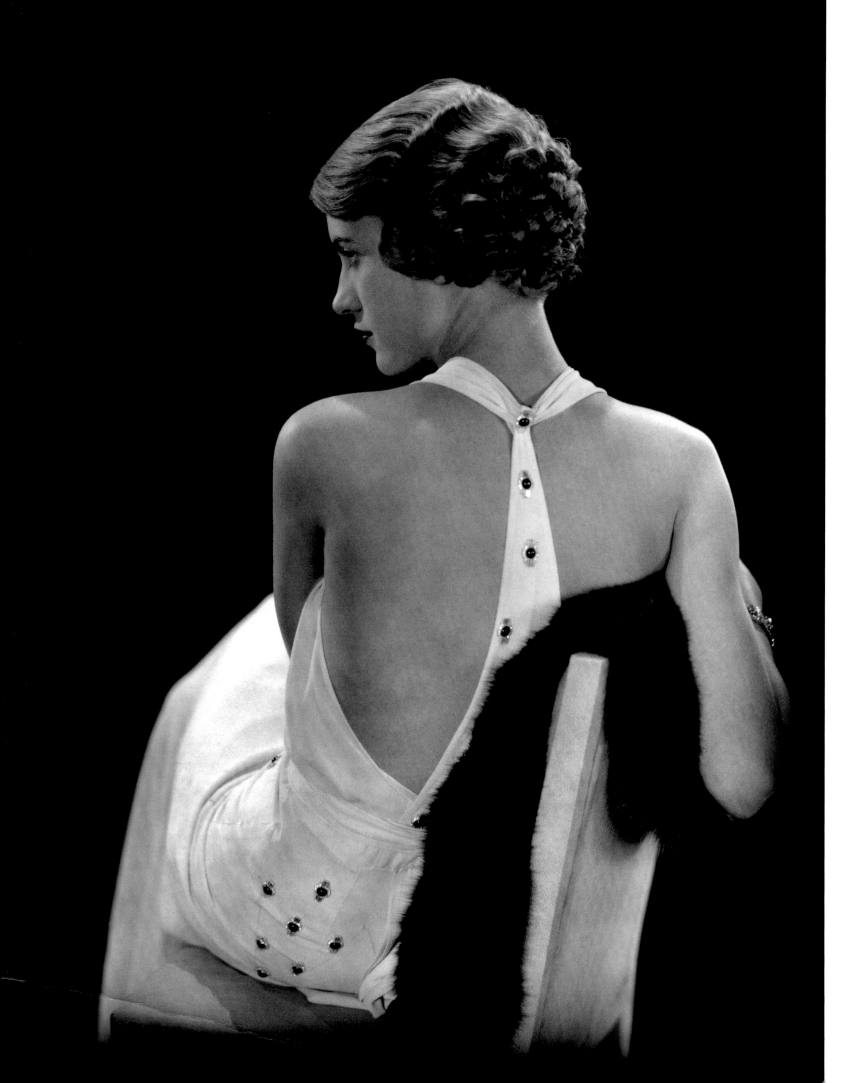

lee miller (1907–1977) had wide-set blue eyes, bobbed hair and a nonchalance that made her one of the country's most famous models in the 1920s; she abandoned it for paris, walked up to man ray in a bar and said, "my name is lee miller and i'm your new student." (he didn't take students. she had never taken pictures.) she went from being his lover and collaborator to shooting some of his fashion photography jobs while he painted. she independently shot collections for coco chanel and elsa schiaparelli and portraits of marlene dietrich and charlie chaplin; meanwhile salvador dalí memorialized her lips in a painting and jean cocteau cast her in his first film. when world war II broke out, she photographed the london blitz, the liberation of paris and concentration camps at buchenwald and dachau from the front lines for *vogue*—the only female combat photographer in europe. she defiantly soaked in hitler's bathtub, her boots on the bathmat covered in mud from fallen berlin and the death camps, and photographed it. she became a gourmet chef at the cordon bleu in paris and threw surrealist dinner parties for friends like picasso and dorothea tanning at her farm in east sussex, england. (sample menu: green chicken, blue spaghetti and pink cauliflower breasts complete with edible nipples.) she once also made marshmallows in coca-cola sauce to annoy an english critic who had told her americans couldn't cook—and when a journalist referred to lee miller as "one of the most photographed girls in manhattan," she retorted, "i'd rather take a picture than be one."

"naturally i took pictures.
what's a girl supposed to do when
a battle lands in her lap?"

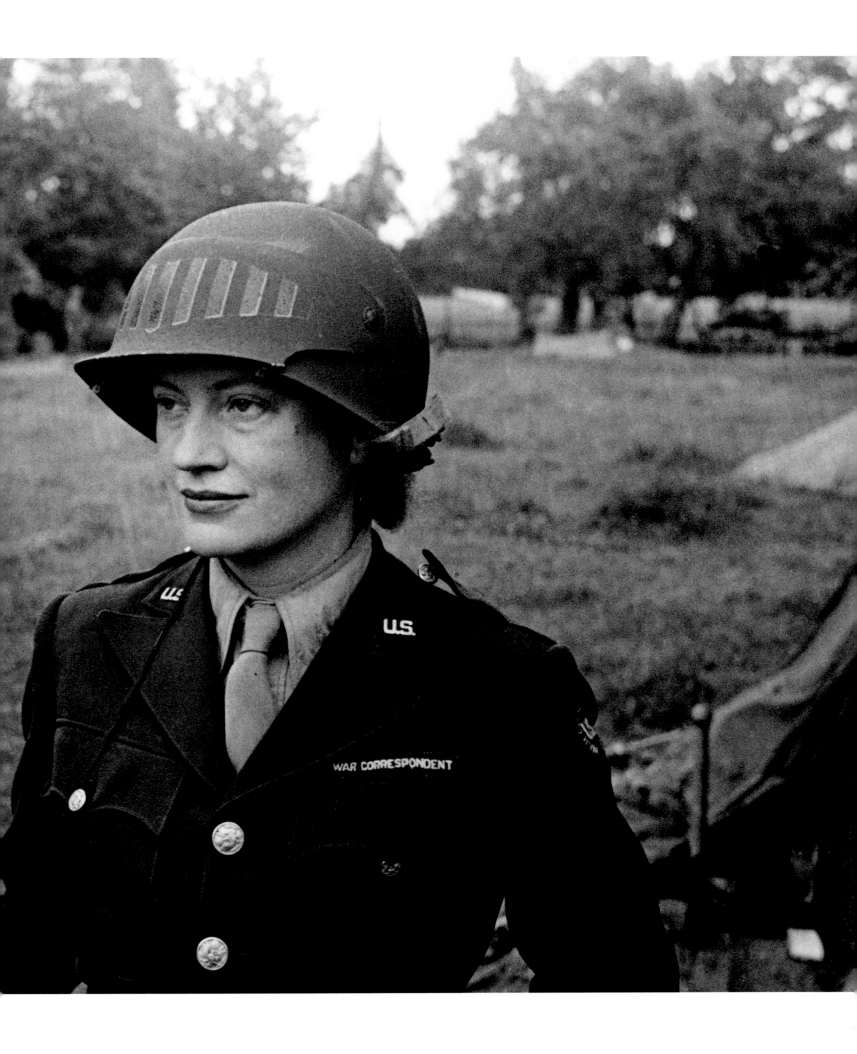

she dives right in.

ruth reichl (1948–) is on a life-long quest to demystify food. she began formally food wordsmithing in 1972, with the cookbook *mmmmm: a feastiary.* she co-owned the swallow collective, a café within the berkeley art museum, and introduced american diners to authentic antipasti and quiche, indonesian and moroccan fare, just-baked breads, housemade chutneys, and fresh vinaigrettes— all adventurous paths for the 1970s palate. she pushed the boundaries of food and its journalism while food editor at the *los angeles times*, restaurant critic at the *new york times* (where she'd go to great lengths to disguise herself while on assignment) and editor-in-chief of *gourmet*, the nation's oldest epicurean magazine. she's written nine books, from cookbooks to memoirs to novels— and even from her upstate new york cabin and kitchen she provides daily inspiration to the world in one hundred forty artful characters or less as a continuing tale of culinary adventure.

A SPRINKLE OF RUTH'S SHORT AND SWEET
ODES TO EATING.

white out in the city. furious snow pelting down.
sound muffled. so lovely. hot cocoa, billows of cream. toasted bagel,
buttery, warm. – @ruthreichl

silver river beneath pewter sky. dogs frisk
through chilly park. cozy café au lait. buttered
tartine. strawberry jam. a NY morning.
– @ruthreichl

golden autumn morning bright with orange leaves.
hawks swoop through pale sky. ginger tea. ripe sliced pears
nestled into rich blue cheese. – @ruthreichl

another rothko morning: blue sky, pink-tinged
swath of fluffy clouds, lush green lawn. wild turkeys strut.
bright peppers. onion. egg. – @ruthreichl

A SPRINKLE OF RUTH'S SHORT AND SWEET
ODES TO EATING.

white out in the city. furious snow pelting down.
sound muffled, so lovely. hot cocoa, billows of cream. toasted bagel,
buttery, warm. — @ruthreichl

silver river beneath pewter sky, dogs frisk
through chilly park. cozy café au lait, buttered
tartine. strawberry jam. a NY morning.
— @ruthreichl

golden autumn morning bright with orange leaves.
hawks swoop through pale sky. ginger tea. ripe sliced pears
nestled into rich blue cheese. — @ruthreichl

another rothko morning: blue sky, pink-tinged
swath of fluffy clouds, lush green lawn. wild turkeys strut.
bright peppers. onion. egg. — @ruthreichl

snack. fig. fresh goat cheese. balsamic
splash. – @ruthreichl

cool night. bright morning. promise of fall in
the air. thickly sliced tomatoes. cold butter. bread. snipped
basil. salt. still summer. – @ruthreichl

august light dapples the lawn. tiny yellow bird darts
past. riot of bright peppers tangled into onions. melting
cheese. poached egg. – @ruthreichl

sweet sultry morning. wood thrush calls. cats prowl
through long grass. congee: dark jeweled beauty of preserved
duck egg. scallion. soy. – @ruthreichl

she ~~meditates~~ daydreams.

"when you take a flower in your
hand and really look at it, it's your world
for the moment. i want to
give that world to someone else."

georgia o'keeffe (1887–1986) created a series of
charcoal drawings in 1915 that started her career and formed
a new visual language that expressed her feelings: she was one
of the first american artists to practice pure abstraction. she
changed her perspective in the hopes of changing ours. "i said to
myself—i'll paint what i see—what the flower is to me but i'll
paint it big and they will be surprised into taking time to look at
it—i will make even busy new yorkers take time to see what i see
in flowers," o'keeffe wrote in an exhibition catalogue, about tiny
petals stretched to fill 30"x40" canvas frames. for twenty years,
starting in 1929, she divided her time between new mexico
and new york. she spent the 1950s and '60s traveling the world
for inspiration, from the peaks of peru to japan's mount fuji
(see: *sky above the clouds, IV* (1965)). she wore minimal kimonos,
wide-lapelled shirts and bespoke black suits; for over sixty years
she painted bright, explosive canvases of southwestern
landscapes, flowers, new york skyscrapers and animal skulls
that shaped american modernism.

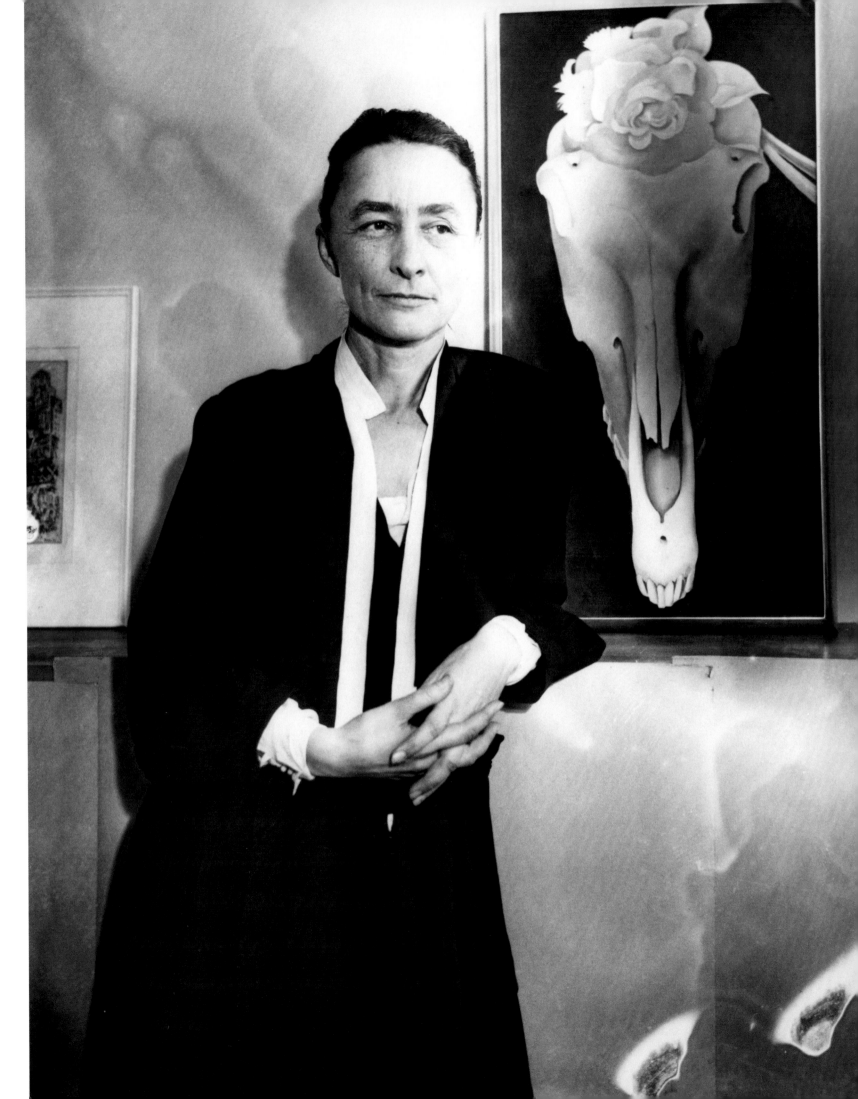

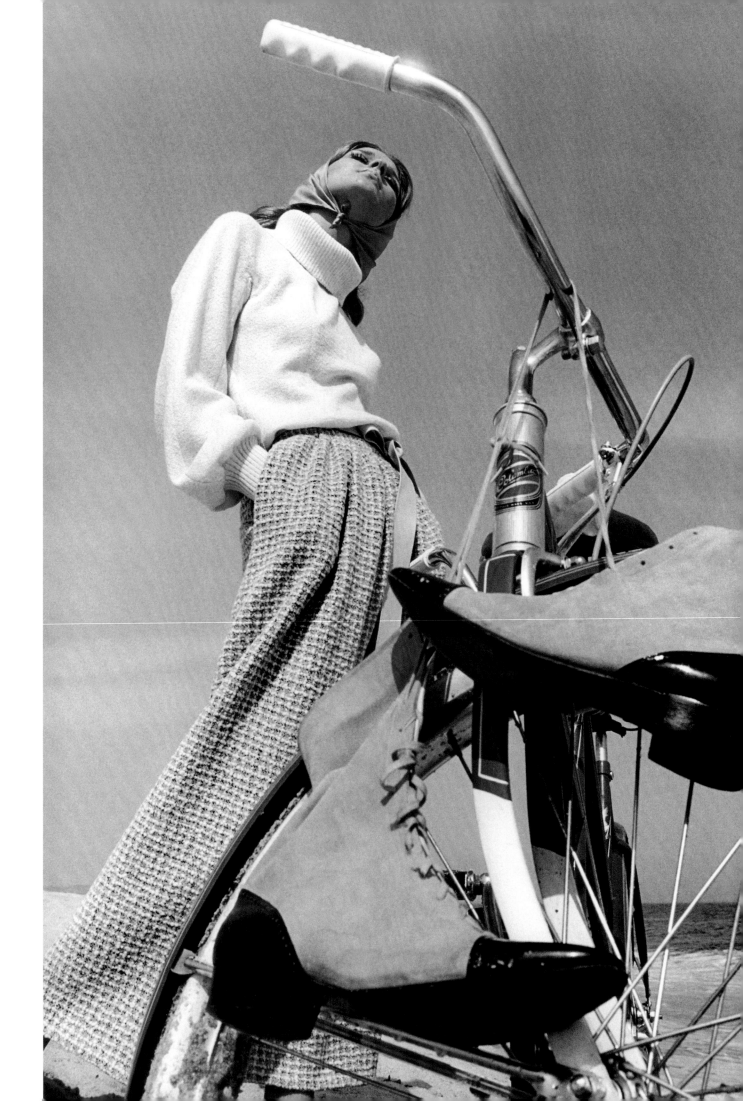

she believes good shoes take her good places.

alice marble (1913–1990) played seven sports by the
time she was a teenager—including boxing, track, baseball and
soccer. she took up lawn tennis because her brother said it was
more "ladylike," and then redefined the sport in the 1930s for
women worldwide with an unrestrained serve-volley-smash game
that people back then dubbed "power tennis" and today call
"tennis." she ranked number one in the world, won twelve US
opens and five wimbledon titles. she coached billie jean king.
when DC comics launched *wonder woman* in 1942, she wrote and
edited the "wonder women of history" centerfold of each issue:
a biography of a real-life female superhero—florence nightingale,
madame chiang kai-shek and sacagawea, for example—in comic
form. she spied for US intelligence during world war II until a
german double agent shot her in the back and she very publicly
challenged racial inequality on her home turf in the 1950s:
"if tennis is a game for ladies and gentlemen, it's also time we
acted a little more like gentle-people and less like sanctimonious
hypocrites," she wrote in *american lawn tennis* magazine. althea
gibson—accomplished jazz singer, saxophone player, actress and
professional golfer as well as tennis player—was subsequently
invited to play in the US open and went on to win
eleven grand-slam crowns.

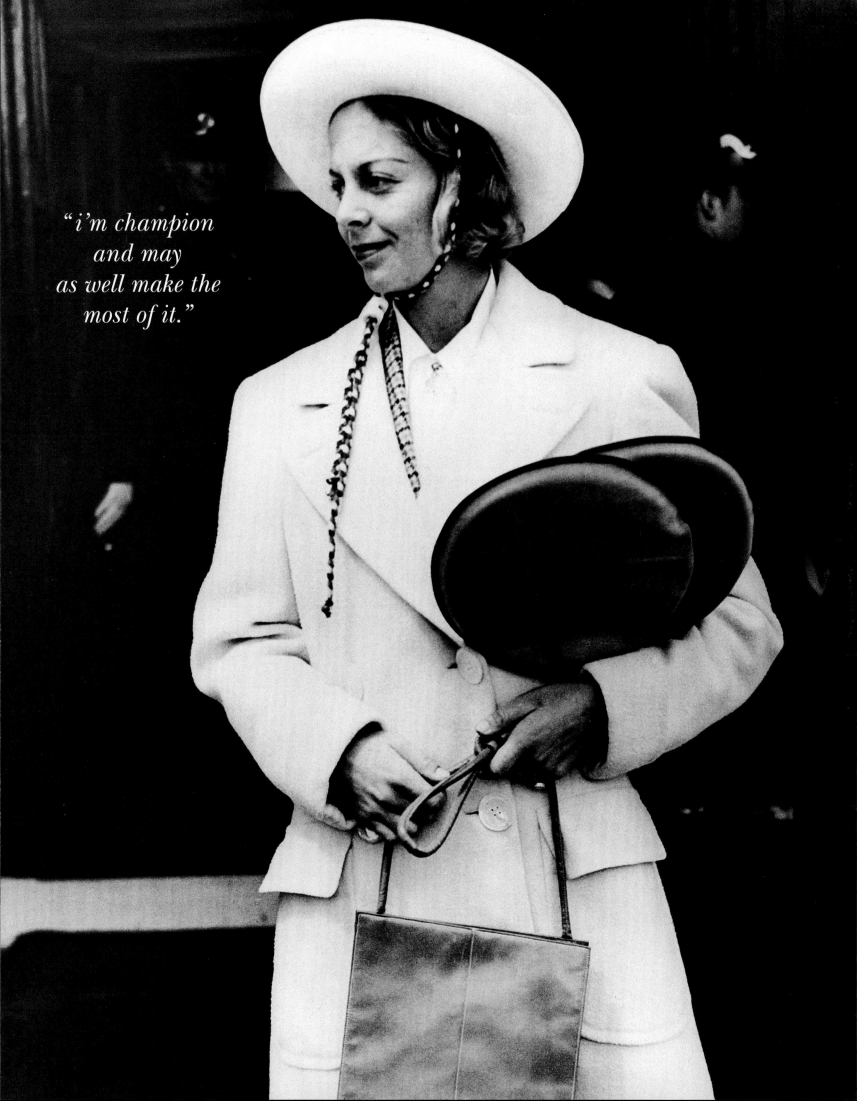

"i'm champion and may as well make the most of it."

9.

she's
the first to give
a toast
and
the last to say
goodbye.

betty halbreich (1927–) is a style original who helps other women define what original style means to them. for forty-one years (since 1976, to be exact), she's run solutions by betty halbreich—her own personal shopping department—at bergdorf goodman in new york city. "for me, dressing someone well is as divine as helping someone to walk, to see, to smile or to bake a tall, light angel food cake," she explains in her memoir, *i'll drink to that*—and her clients range from first ladies and hollywood starlets to executives and women who simply want to look stunning. she helped patricia field dress the characters of *sex and the city*. she explores all eight floors of bergdorf first thing every morning, five days a week—including the concrete-floored, florescent-lit stockrooms. she works *sans* mobile phone, *sans* computer. she speaks frankly, with love. at 89, she partially credits proper dinners at home ("i've never used a paper napkin in my life") and two vodkas a night for her longevity. she also believes that if you aren't enjoying your clothes you're missing the whole point.

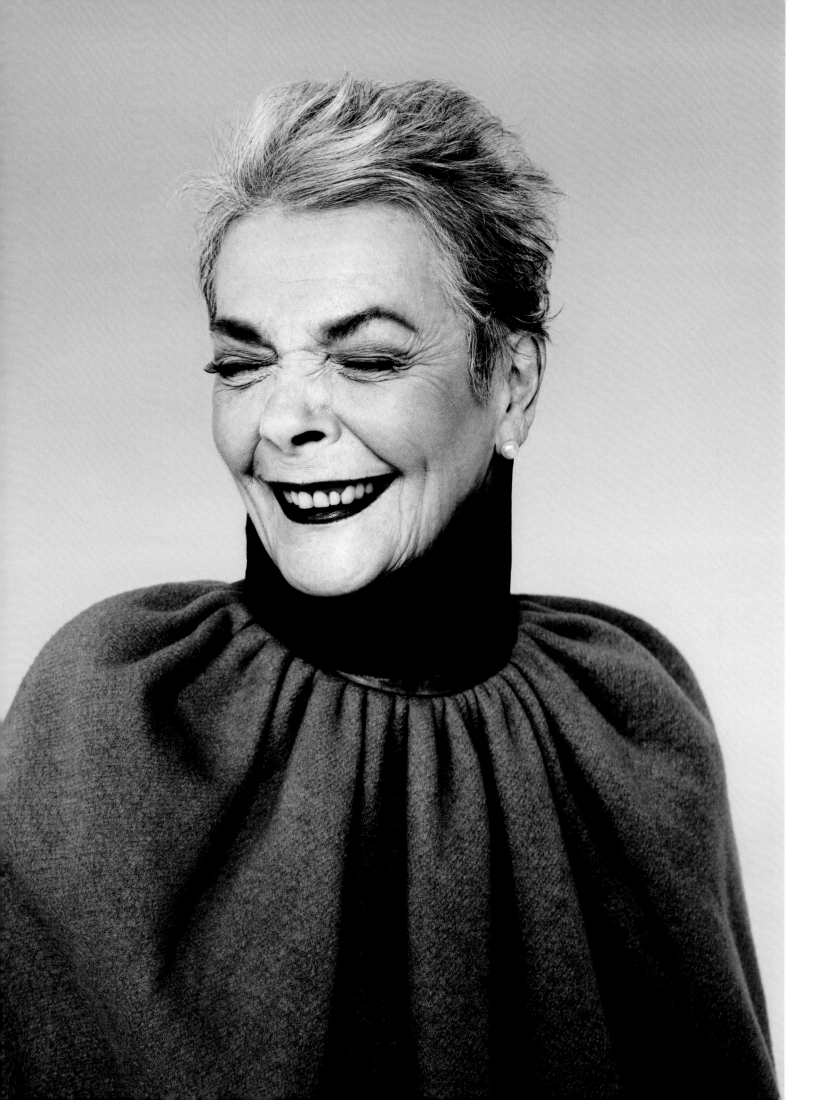

she prefers both her drinks and her conversation to be sparkling.

rita moreno (1931–) is a singer, dancer and actress
who made her first appearance on broadway at age 13. she won
an oscar for her performance in *west side story*. (she's one of
just a dozen to have been awarded a tony, an emmy and a grammy
award, too.) she was an original cast member of the PBS kids'
show *the electric company* and danced with animal on *the muppet
show*. she did the audio recording of supreme court associate
justice sonia sotomayor's 2013 memoir, *my beloved world*, and has
sung at the white house. she's served as a commissioner on
the national endowment for the arts and as a member of the
president's committee on the arts and humanities. she and her
family moved from puerto rico to the bronx when she was 5;
sixty-eight years later, she received the presidential medal of
freedom for her contribution to the arts.

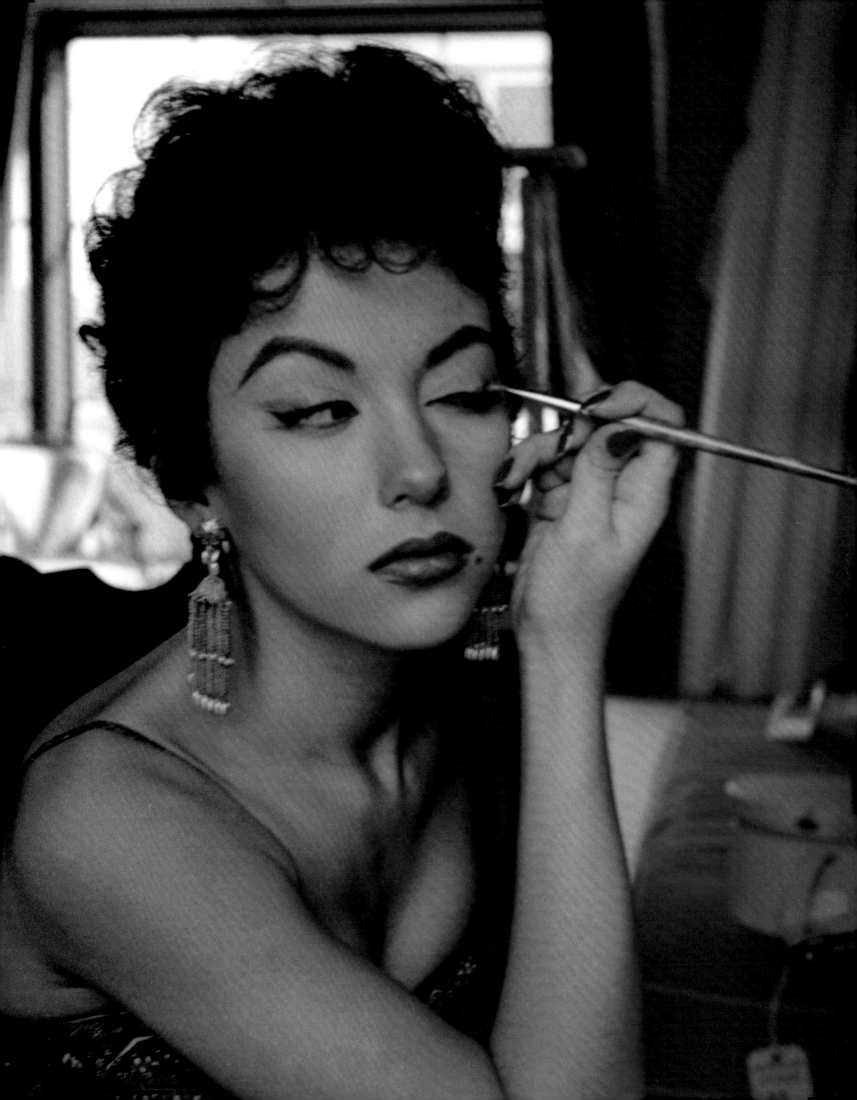

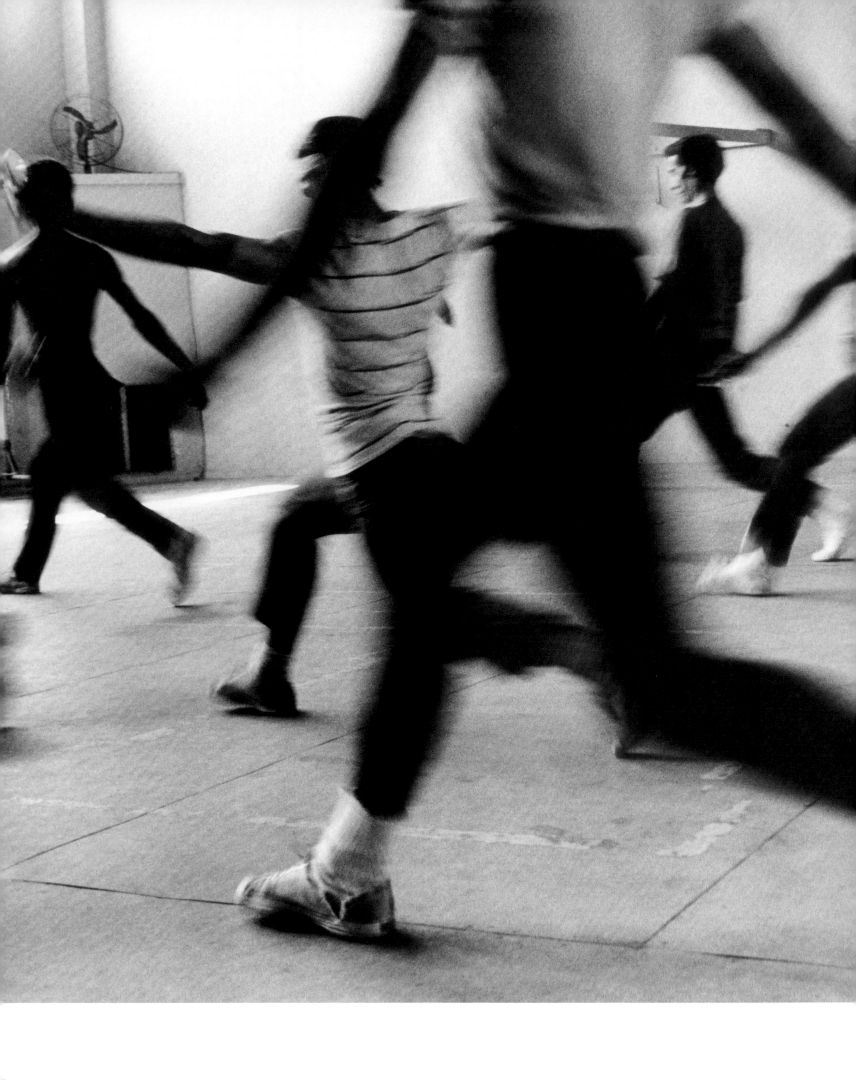

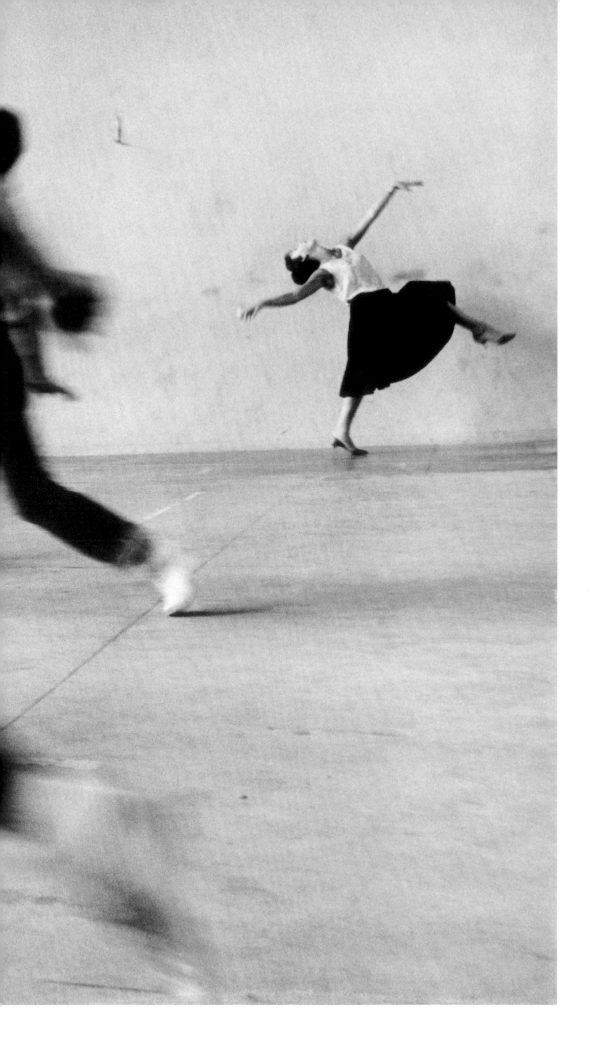

"bigger than life is
not difficult
for me. i am bigger
than life."

—*rita moreno*

nancy "slim" keith (1917–1990) was an inspiration. in the film *to have and have not*, lauren bacall may have been the one to ask humphrey bogart "you know how to whistle, don't you?" but those were slim's words she spoke. slim's cooly-tailored clothes she wore, too. her character shared slim's name and it was slim who said that the *harper's bazaar* cover girl was hollywood material in the first place. slim was director and first husband howard hawks's exemplar for silver screen heroines, truman capote's witty muse, ernest hemingway's stylish hunting partner and clark gable's—and many other's—crush. she held court with diana vreeland at cocktail parties. her golden glow and crisp scrubbed-clean style made her the original "california girl." and on the occasion clark sent her a postcard that read, "you were wonderful," she explained the suggestive note to her quizzical then-boyfriend as "i was just wonderful being wonderful."

"i thought it was more important to have an intelligence that showed,

a humor that never failed, and a healthy interest in men."

—*slim keith*

mame dennis (*auntie mame*, 1958) was the glamorous, eccentric, witty and "intoxicatingly perfumed" (according to the 1955 book) aunt of orphan patrick dennis. whether at the height of her fortune or in the lows of the great depression, she believed in defying convention, taking roads less traveled, trying things (experimental schools, languages, flaming cocktails), and she introduced her nephew to a world filled with madcap adventures, eccentric characters and a (champagne) glass half-full mentality. her motto: "life is a banquet!"

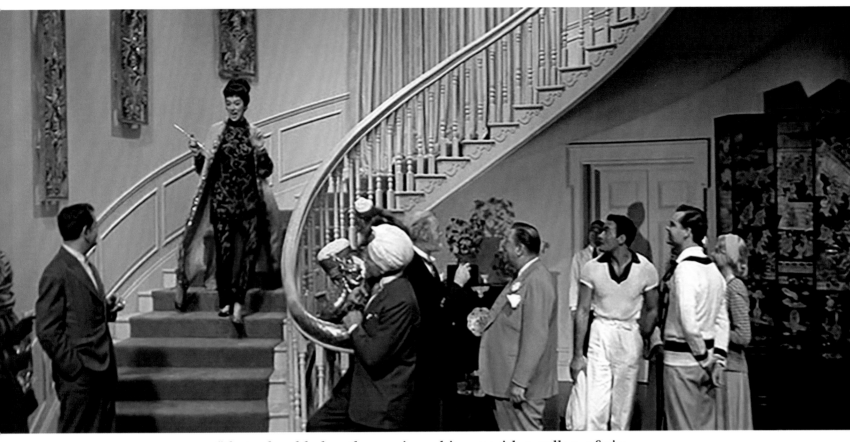

"that adorable bootlegger is on his way with a gallon of gin.
oh, allen, darling! edna, i called you yesterday."

"hello, mame."
" i'll be with you in a minute."

she makes grand gestures instead of small talk.

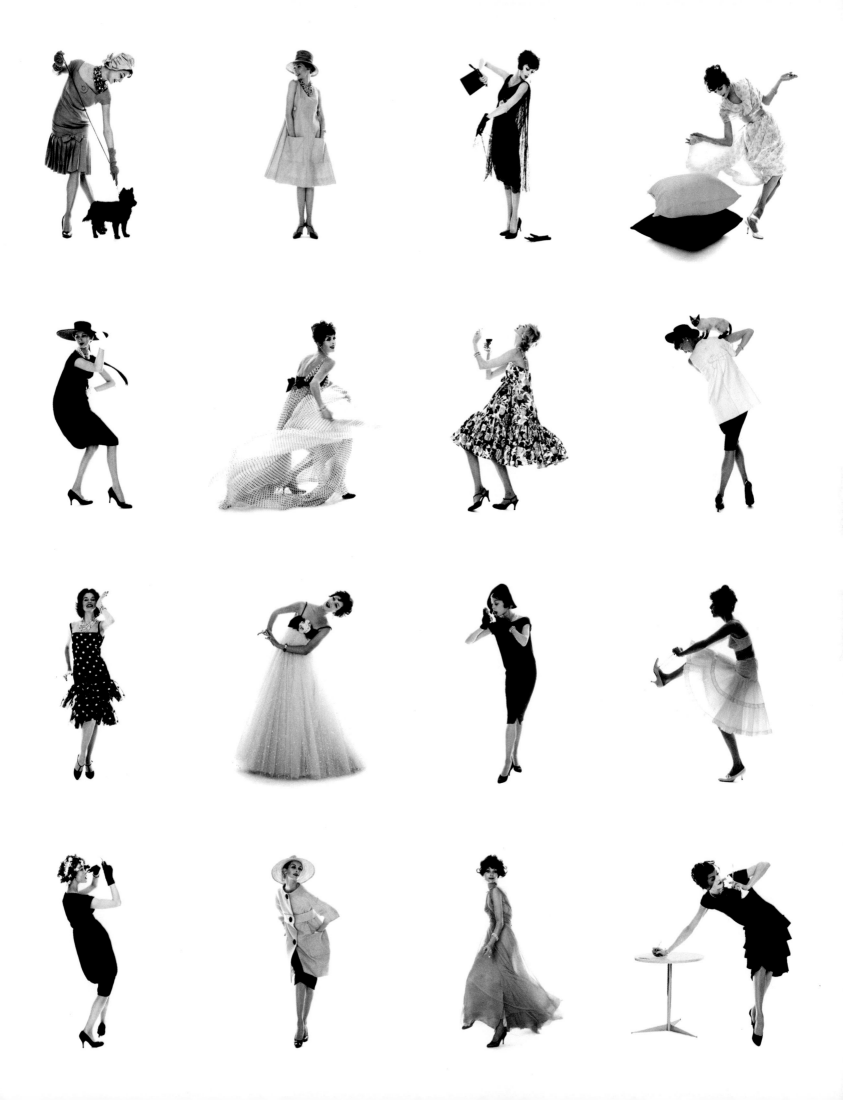

once, we walked all the way to chinatown, ate a
chow-mein supper, bought some paper lanterns and stole a box
of joss sticks, then moseyed across the brooklyn bridge,
and on the bridge, as we watched seaward-moving ships pass between
the cliffs of burning skyline, she said: "… i love new york,
even though it isn't mine, the way something has to be, a tree or
a street or a house, something, anyway, that belongs to me
because i belong to it." and i said, "do shut up,"
for i felt infuriatingly left out—a tugboat in dry-dock while

she, glittery voyager
of secure destination, steamed down
the harbor with whistles
whistling and confetti in the air.

—*holly golightly of* breakfast at tiffany's, *1958*

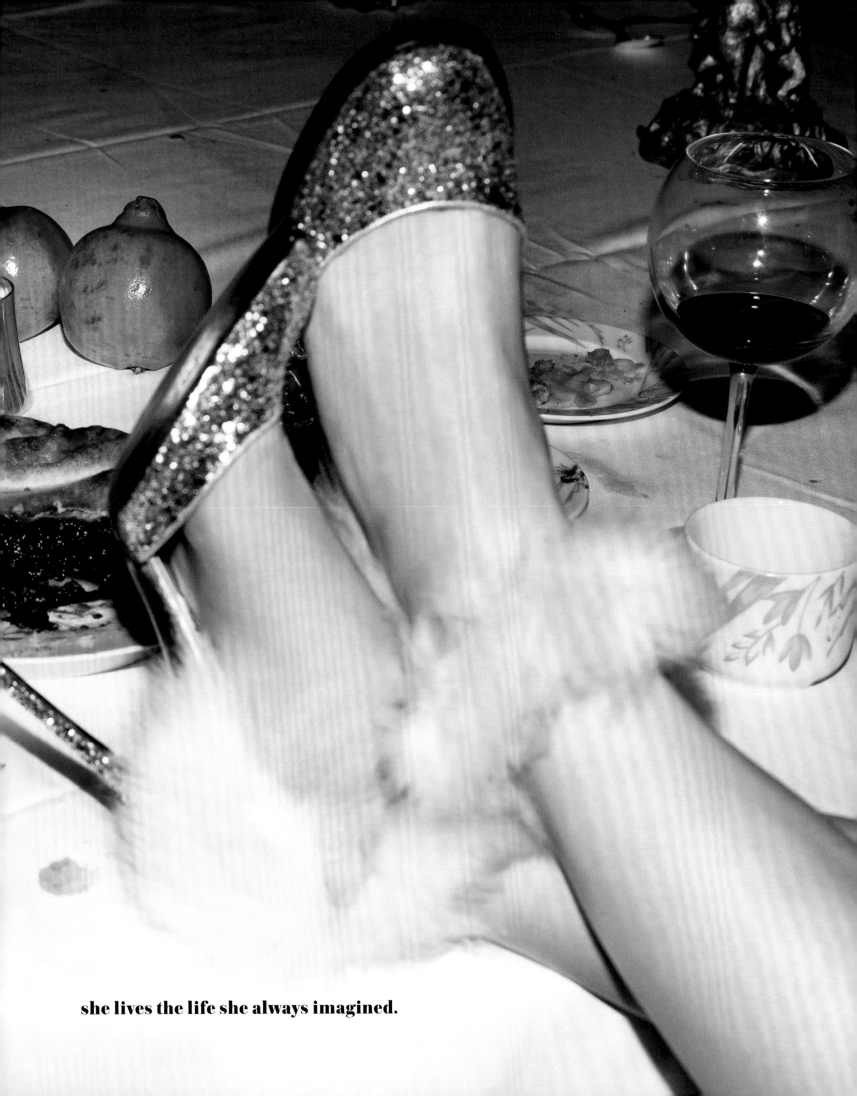

she lives the life she always imagined.

to be continued...

124

126

128

130

132

134

136

138

140

142

144

146

148

150

152

154

156

158

160

162

164

166

168

170

172

174

176

178

CREDITS

97
image provided courtesy of dorothy draper & company, inc.

98
photography by jessica craig-martin

100
© estate of lillian bassman

102–103
© estate of lillian bassman

104
patrick demarchelier / *vogue* © condé nast

106
© julian wasser

110–111
flower drum song: universal pictures / photofest

113
richard gummere / *new york post* archives / © NYP holdings, inc. via getty images

114
susan wood / getty images

116
photograph by tommy ton

118
AP photo

121
collection of the smithsonian national museum of african american history and culture. gifted with pride from ellen brooks

123
condé nast ltd - arthur elgort / trunk archive

124
david redfern / redferns

129
camilla akrans / trunk archive

130
jane bown / *the guardian*

132
1960 © eve arnold for AP / magnum photos

134
© tim walker

136
photo by nickolas muray © nickolas muray photo archives

138
photograph by irving penn for the february 15, 1970 issue of *vogue* / © CN

140
lakin ogunbanwo

142
camilla akrans / trunk archive

144
© emma summerton

148
harper's bazaar may 1968 cathee dahmen in castillo © neal barr

150
hulton archive / getty images

152
harry ransom center / the university of texas at austin

153
photograph by jorge concha

154
gino begotti / camera press / redux

156
© estate jeanloup sieff

158
phil oh

163
photo by metro-goldwyn-mayer / getty images

164
condé nast ltd - michael wickham / trunk archive

167
paul schutzer / the *LIFE* images collection / getty images

168
photograph by gosta peterson. naomi sims with halston hat and cape for "fashions of the times" august 27, 1967

170-171
clueless: paramount pictures / photofest

172
girl in bath (jean patchett), new york, 1950 / © condé nast

175
© philippe halsman / magnum photos

176
barry mckinley, *harpers and queens*, may 1974

178
photo by osa & martin johnson / george eastman house / getty images

181
john elwell and telegraph

185
naty abascal, earrings by castlecliff, watch by piaget, and hair by monti rock III, new york, december 21, 1964

photograph by richard avedon

© the richard avedon foundation

186
photo-hoyningen-huene © horst

188
© courtesy lee miller archives, england 2016. all rights reserved. leemiller.co.uk

191
jean-daniel lorieux

193
jennifer livingston / trunk archive

196
photograph by irving penn for
the july 1, 1950 issue of *vogue* / © CN

199
© 2017 georgia o'keeffe museum /
artists rights society (ARS), new york

bettmann / getty

200
© estate jeanloup sieff

203
ACME

204
photograph by john rawlings. courtesy
of the museum at FIT

207
ruven afanador / CPi syndication

208
© stephen lewis /
art + commerce

211
loomis dean / the *LIFE* picture
collection / getty images

212
© phil stern, philip stern trust

214
photography by jessica craig-martin

216
bettmann / getty images

221
auntie mame. warner bros. / photofest

223
jerry schatzberg / trunk archive

226
photography by jessica craig-martin

SOURCES

14
fonda, jane. *jane fonda's workout book.*
simon & schuster. november 1981.

18-19
iverson, kristen. "the people in
your neighborhood: sarah sophie
flicker." bkmag.com. june 5, 2014.
retrieved 19 october 2016. bkmag.
com/2014/06/05/the-people-in-your-
neighborhood-sarah-sophie-flicker/

28
facebook.com/dollyparton

30-31
frank, alex. "15 minutes with dolly
parton." vogue.com. 10 august 2016.
retrieved 9 september 2016. vogue.
com/13465084/dolly-parton-interview-
album-tour/

40
all by myself: the eartha kitt story.
christian blackwood, dir. 1982.

42
recently, i was at: sciortino, karley.
email. 3 october 2016.

45
lambert, bruce. "millicent fenwick, 82
dies; gave character to congress." *the new
york times.* 17 september 1992.

51
real danger: steinem, gloria. "the moral
disarmament of betty co-ed." *esquire.*
september 1962.

active feminist: pogrebin, abigail.
"an oral history of ms. magazine."
new york magazine. 20 october 2011.

role of a writer: gilbert, lynn. *particular
passions: gloria steinem.* lynn gilbert inc.
january 2012.

recognizes the equality: hepola, sarah.
"gloria steinem, a woman like no other."
the new york times. 16 march 2012.

refused service, no one knows about,
future depends and listen: steinem,
gloria. *my life on the road.* random house.
october 2012.

i didn't change: mustafa, zubeida.
"still talking, writing and connecting."
dawn. karachi. 25 march 2007.

more than poverty: *woman*
trailer. viceland. youtube.com/
watch?v=I7DbPE4salw

54
astonishes me: benwell, maxwell. "zora
neale hurston celebrated in the US
with a google doodle on her birthday."
the independent. 7 january 2014.

color struck: zoranealehurston.com

something to say: neale hurston, zora.
*zora neale hurston: novels and stories:
jonah's gourd vine / their eyes were
watching god / moses, man of the
mountain / seraph on the suwanee /
selected stories.* 1995.

56
miss piggy. "miss piggy: why i am a
feminist pig." time.com. 4 june 2015.
retrieved 1 october 2016.

60
vreeland, diana. *D.V.* random house,
1986.

63
vreeland, diana. *D.V.* random house,
1986.

swoonsuits and thinking: "legacy."
dianavreeland.com. retrieved 1
december 2016.

macnab, geoffrey. "diana vreeland: a
sacred monster." independent.co.uk. 4
june 2012. retrieved 1 december 2016.

66
look like america: *chasing news.* bianchi,
dennis. mynetworkTV. WWOR-TV. 1
march 2016.

69
militant and housewife: alexiou, alice
sparberg. *jane jacobs: urban visionary.*
rutgers university press. may 11, 2006.

small-scale: gopnik, adam.
"jane jacobs's street smarts." *the new
yorker.* 26 september 2016.

70-71
jacobs, jane. "downtown is for the
people." *fortune* magazine. 1958.

74
heidman, kelly. "annie easley, computer
scientist." nasa.gov. 21 september 2015.
retrieved 23 december 2016.

76-77
"you've got a friend." *the mary tyler
moore show.* jerry belson, dir.
james l. brooks, allan burns, writers.
starring mary tyler moore, nanette
fabray, bill quinn. MTM enterprises.
25 november 1972.

79
"katharine hepburn biography."
biography.com. retrieved 12 november
2016.

82
wilkinson, isabel. "iris apfel on
individuality, her new movie and being
famous." nymag.com. 15 april 2015.
retrieved 2 october 2016.

85
"the wendy williams show." wendy
williams, host. 19 july 2016.

88
greatest star: douglas, illeana. *i blame
dennis hopper: and other stories from a life
lived in and out of the movies.* flatiron
books. 2015.

where there is love: taylor, elizabeth.
"elizabeth taylor at the GLAAD media
awards." 2 april 2000. online video clip.
eonline.com. accessed 17 november
2016. eonline.com/news/233062/
new-video-watch-elizabeth-taylor-s-
pioneering-gay-rights-speech

90
cott, jonathan. "elizabeth taylor: the lost interview." *rolling stone.* 14 april 2011.

94-96
run free: "ex and the city." *sex and the city.* michael patrick king, dir. and writer. starring sarah jessica parker. HBO. 3 october 1999.

where does the love go: serrano, shea. "drake's new album using sex and the city gifs. " villagevoice.com. 24 september 2013. retrieved 14 december 2016. villagevoice.com/music/drakes-new-album-reviewed-using-sex-and-the-city-gifs-6637706

97
"new york news: the most popular interior designer in mid-20th-century new york was a committed mutilator of antique furniture—as a new exhibition reveals." the free library. 2006 *apollo* magazine ltd. retrieved 27 november 2017. www.thefreelibrary.com/New+ York+news%3a+the+most+popular+ interior+designer+in+mid-20th-century... -a0147215589

102
teeman, tim. "lillian bassman: 'the models didn't have to flirt with me.'" *the times magazine.* 7 may 2011.

106
social hemorrhaging: didion, joan. *slouching towards bethlehem: essays.* farrar, straus and giroux. 28 october 2008.

i write: trombetta, sadie. "11 writing tips from joan didion because she knows a thing or two about it." bustle.com. 15 september 2016. retrieved 12 november 2016. bustle.com/articles/182458-11-writing-tips-from-joan-didion-because-she-knows-a-thing-or-two-about-it

108-109
didion, joan. *slouching towards bethlehem: essays.* farrar, straus and giroux. 28 october 2008.

112
bellafante, ginia. "a pioneer in a mad men's world." *the new york times.* 8 june 2012.

114
horovitz, bruce. "queen of advertising tells all." *USA today.* 2 may 2002.

120
unbought and unbossed: "shirley chisholm." americanradioworks. publicradio.org. retrieved 4 november 2016. americanradioworks.publicradio. org/features/blackspeech/ schisholm-2.html

brooklyn: baron, james. "shirley chisholm, 'unbossed' pioneer in congress, is dead at 80." *the new york times.* 3 january 2005.

values: "chisholm, shirley anita." history.house.gov. retrieved 2 october 2016. history.house.gov/people/ listing/C/CHISHOLM,-shirley-anita- (C000371)/

happy little homemaker: united states congress. *the "equal rights" amendment. hearings before the subcommittee on constitutional amendments of the committee on the judiciary united states senate. ninety-first congress. second session.* may 5, 6, and 7, 1970. archive.org. retrieved 3 november 2016. archive.org/details/ equalrightsamend00unit

national figure, courses in civil rights, role is a catalyst and leader: chisholm, shirley. *unbought and unbossed: expanded 40th anniversary edition.* take root media. 20 january 2010.

fight for justice: wasniewskie, matthew, ed. *black americans in congress, 1870—2007.* united states congress. 3 october 2008.

121
important to say: "chisholm '72: film description." pbs.org. 7 february 2005. retrieved 4 november 2016. pbs.org/ pov/chisholm/film-description/

helped pave it: "shirley chisholm." americanradioworks.publicradio. org. retrieved 4 november 2016. americanradioworks.publicradio.org/ features/blackspeech/schisholm-2.html

break new ground and engage in compromise: "chisholm, shirley anita." history.house.gov. retrieved 2 october 2016. history.house.gov/people/ listing/C/CHISHOLM,-shirley-anita- (C000371)/

126
nina simone great performances: live college concerts and interviews. andy stroud, dir. sound dimensions, nyc. 25 march 2009.

131
arnold, eve. interview with john tusa. "the john tusa interviews: eve arnold." john tusa. BBC radio 3. 4 september 2001. bbc.co.uk/programmes/ p00nc1bw

140
be true: ngozi adichie, chimamanda. 13 december 2016. email.

now is the time: ngozi adichie, chimamanda. "now is the time to talk about what we are actually talking about." *the new yorker.* 2 december 2016.

people make culture: ngozi adichie, chimamanda. *we should all be feminists.* anchor. 2015.

144
kallman, amelia. "emma summerton." diaryofalondonshowgirl.tumblr. com. retrieved 1 december 2016. diaryofalondonshowgirl.tumblr.com/ emmasummerton

147
summerton, emma. 10 january 2017. email.

151
nemy, enid. "fleur cowls, 101, is dead; friend of the elite and the editor of a magazine for them." *the new york times.* 8 june 2009.

155
miranda, carolina. "peggy guggenheim wasn't just outrageous and flamboyant; she was a true arts patron." latimes.com. 13 november 2015. retrieved 12 november 2016. latimes.com/entertainment/arts/miranda/la-et-cam-peggy-guggenheim-art-addict-20151111-column.html

160-161
medine, leandra. 13 december 2016. email.

170-171
clueless. heckerling, amy, dir. starring alicia silverstone. paramount pictures. 1995.

174
houghton, kristen. "happiness means loving yourself." huffingtonpost.com. 6 october 2011. retrieved 1 january 2017. huffingtonpost.com/kristen-houghton/learn-to-love-yourself_b_996885.html

179
1,000 thrills: "jungle adventures (1921): overview." tcm.com retrieved 14 december 2016. tcm.com/tcmdb/title/579278/jungle-adventures/

queen of the jungle: "osa johnson dies; a noted explorer." obit. *the new york times.* 8 january 1953.

180
benson, linda. november 2016. telephone.

183
benson, linda. november 2016. telephone.

186
my name is: davies, lucy. "lee miller and man ray: crazy in love." telegraph.co.uk. 12 july 2011. retrieved 20 december 2016. telegraph.co.uk/culture/photography/8623206/lee-miller-and-man-ray-crazy-in-love.html

be a picture: horyn, cathy. "lee miller: light on her fashion." blogs.nytimes.com. 16 august 2013. retrieved 10 october 2016. runway.blogs.nytimes.com/2013/08/16/lee-miller-light-on-her-fashion/

188
codinha, alessandra. "why the fearless vogue model, war correspondent, and muse lee miller is our fall style inspiration." vogue.com. 15 august 2014. retrieved 11 october 2016. vogue.com/977361/lee-miller-photographer-model-war-correspondent-style-icon/

194
white out: reichl, ruth. twitter.com/ruthreichl. 7 january 2017. retrieved 12 january 2017.

silver river: reichl, ruth. twitter.com/ruthreichl. 7 december 2016. retrieved 12 january 2017.

golden autumn: reichl, ruth. twitter.com/ruthreichl. 21 october 2016. retrieved 12 january 2017.

rothko morning: reichl, ruth. twitter.com/ruthreichl. 24 september 2016. retrieved 12 january 2017.

195
snack. fig.: reichl, ruth. twitter.com/ruthreichl. 7 september 2016. retrieved 12 january 2017.

cool night.: reichl, ruth. twitter.com/ruthreichl. 4 september 2016. retrieved 12 january 2017.

august light: reichl, ruth. twitter.com/ruthreichl. 27 august 2016. retrieved 12 january 2017.

sweet sultry morning: reichl, ruth. twitter.com/ruthreichl. 16 june 2016. retrieved 12 january 2017.

198
georgia o'keeffe estate. 23 january 2017. email.

203
fein, paul. *tennis confidential II.* potomac books. 28 april 2008.

206
angel food cake: halbreich, betty. *i'll drink to that: a life in style, with a twist.* penguin books. 25 august 2015.

paper napkin: "bergdorf's betty halbreich on joan rivers, white jeans and never ordering takeout." thenewpotato.com. 2 june 2015. retrieved 12 november 2016. thenewpotato.com/2015/06/02/betty-halbreich-bergdorf-goodman-2015

213
roiz, jessica lucia. "happy 84th birthday rita moreno." latintimes.com. 11 december 2015. retrieved 9 december 2016. latintimes.com/pulse/happy-84th-birthday-rita-moreno-19-memorable-quotes-puerto-rican-actress-358053

217
california girl: koski, lorna. "style setters: slim keith." wwd.com. 14 may 2015. retrieved 19 october 2016. wwd.com/eye/other/style-setters-slim-keith-10125067/

wonderful: keith, slim. *slim: memories of a rich and imperfect life.* simon & schuster. july 1990.

218-219
keith, slim. *slim: memories of a rich and imperfect life.* simon & schuster. july 1990.

220
auntie mame. dacosta, morton, dir. starring rosalind russell. warner bros. 27 december 1958.

225
capote, truman. *breakfast at tiffany's.* knopf doubleday. 28 september 1993.

senior director, editorial
jen ford

designer
julie weiss design

photo editor
melissa goldstein

production managers
katherine di leo, kelly sandoval

contributing writers
emily coleman, amy perry

special thanks
if there's one thing this project reminded us of, it's that when people come together,
beautiful things happen. people like our CMO mary beech and VP of brand creative kristen naiman,
who both championed this project long before day one. carolina paschoal and chinyere ndukwe,
who gave thoughtful counsel. lalena luba and bridget kaczmarek made inspiring connections, and when
billy concha showed us his flair for photography, he made our day—and our book that
much richer. stephanie friese sorted through logistics. phillip duncan ensured everything looked as vibrant
as it felt. joele cuyler helped julie make our design dreams a reality. jolanta alberty delved
into research. and deborah lloyd. she inspires us all every day to lead more interesting lives—
and to celebrate the unique lives of women everywhere.